HENRI CARTIER-BRESSON

PORTRAITS

André Pieyre de Mandiargues and Ferdinando Scianna

HENRI

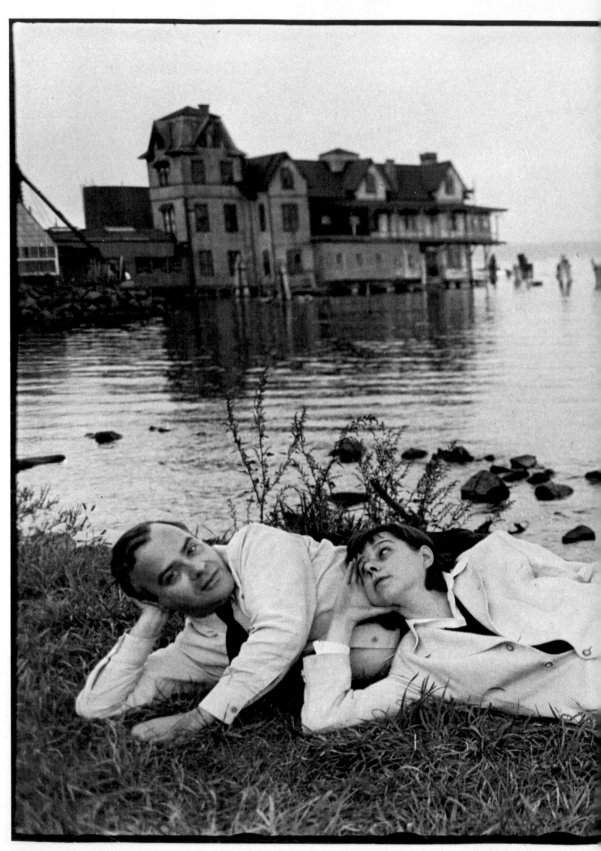

George Davis and Carson McCullers, 1946

CARTIER-BRESSON

PORTRAITS

COLLINS

HENRI CARTIER-BRESSON
The great revealer

by André Pieyre de Mandiargues

Henri Cartier-Bresson

I never come across Henri Cartier-Bresson without thinking of the years 1930, 1931 and after, when in the course of our travels together throughout Europe and digressions through Paris, I saw the greatest photographer of modern times come into being. A kind of spontaneous activity, almost a game at first, had acquired a hold on this young painter, as poetry does with other young people. This happened without any idea of making a profitable career of it for—to we two *petits-bourgeois* youths, barely out of adolescence and freed of the constraints of 'good society'—the very words career and even occupation made us at best feel quite sick! Something which our families were beginning to notice, not without some concern . . .

Time passed. H. C-B., with the Sun in Leo, rapidly crystallized—thanks to photography I believe—into the ardent, impulsive, energetic genius he was destined to become.

A prisoner of war in Germany, he escaped at the third attempt and took part in the underground movement to assist prisoners and escapees. Then, from 1944, he joined the professionals photographing the liberation of Paris. He subsequently left for the United States, to put the finishing touches to a 'posthumous' exhibition organized on the initiative of the Museum of Modern Art in New York, who believed him lost in the war. This exhibition was accompanied by a monograph which was the first major publication devoted to him.

Henceforth, H. C-B. had found his vocation. And how much more meaning and dignity this word has than those of career and occupation which I have already denounced. He is a photographer. A photographer who is different from all the rest because he is always original in everything he does. When Verve published his first great album of photographs in France in 1952, with a cover by Matisse, did he not choose far too modest a title for his work, images and text: *Images à la sauvette* (surreptitious images)? I have never known H. C-B. be surreptitious about anything—except escaping from prisoner-of-war camps. He is not a surreptitious person. Rather, he seizes things in passing and what he has seized is left with a value in terms of human testimony that is overwhelming.

Like the heroes of Guillaume Apollinaire's finest poems, H. C-B. is first and foremost an inspired passer-by, swift in his movements as Apollinaire was in his words and, like the latter, what he is avidly seeking is a veritable sum of revealing images, capable of turning the apparent banality of our universe inside out like a dirty sock, to discover and draw attention to its secret reality. He works with much humour, and some cruelty, as is needed to represent this universe and the more or less remarkable characters which people it.

A great deal has been written about this first part of H. C-B.'s art. I merely wish to emphasize that H. C-B. has nothing of the aesthete. He is never looking for the picturesque image. The beauty of the image for him is in the unveiling of a certain mystery and the shock of a certain fantasy, in which the tragic is mingled with the comic, rather as in literature, in the best stories of Hoffmann, Balzac, Kafka and Blanchot. From all these images—in which quite extraordinary faces are to some extent 'justified' by their setting or the objects around them—H. C-B. passed to the genuine portrait; that is, the photograph of the face or entire body of individuals who interest him for reasons other than their plasticity.

The importance of this monograph is that it shows, once again, that H. C-B., in portraiture as elsewhere, is quite different from other photographers, and that the beauty of the faces reproduced by his camera is nearly always dramatic rather than graceful, as is the case, for example, with the features of the women, artists and

poets pictured by the lens of Man Ray, whom I also greatly admire.

But most of these (usually famous) characters, taken by the little machine which H. C-B. was never without in those days, look as though they have been struck by a wand—magic or otherwise, as you prefer. Glorified, perhaps, they seem frozen for a long time, if not for an eternity, by a kind of gunshot. Grateful to H. C-B.— they would be thoroughly ungracious not to be—and yet they are also his victims. As in the case of the very great writers with whom I have compared him, there is a touch of sadism in the eye and camera lens of H. C-B.

More—or better—still: there is something metaphysical in these portraits. All these well-known faces appear to have received a revelation about their destiny which leaves them mid-way between anxiety and resignation. The one which I prefer, or the one I find most moving, from this point of view, is that of the Joliot-Curie's—husband and wife, each with hands clasped or almost so, face drawn, as if awaiting something about which they have a presentiment but which cannot be uttered, their eyes literally held to the camera lens by an invisible wire (page 48). Never, in all the old paintings of the Annunciation, has one seen such a disquieting expression.

'Glorified, perhaps, they seem frozen for a long time, if not for an eternity, by a kind of gunshot.'

François Mauriac, hands more-or-less clasped as well, is more comfortable as he waits, thanks to the back of his armchair (page 43). But the tilted head, pursed lips and lost look clearly say that the angel has passed this way as well. Sartre on the banks of the Seine must have seen the abyss yawning in front of him (page 37). Matisse shelters as best he can behind his doves, and Pierre Bonnard bows to what was to be a magnificent fate (both page 54). Let us not forget Pierre Colle in his bed, his face hidden behind the sheet, with three shoes lying about dreadfully on the floor—those of the dying man, I thought, and that of the one-footed angel (page 20). André Breton is smiling to himself, but in what a strange way, as he toys with his African and Polynesian statuettes. He seems to have remained intact before the revealing lens, which does not surprise me at all, for I shall always regard him as in a class of his own (page 7).

All these portraits by H. C-B., which are worthy of being touched on one by one, are, I repeat, fantastic as well as admirable, not just as black-and-white photographs, but in terms of their inner vision.

THE PHOTOGRAPHS

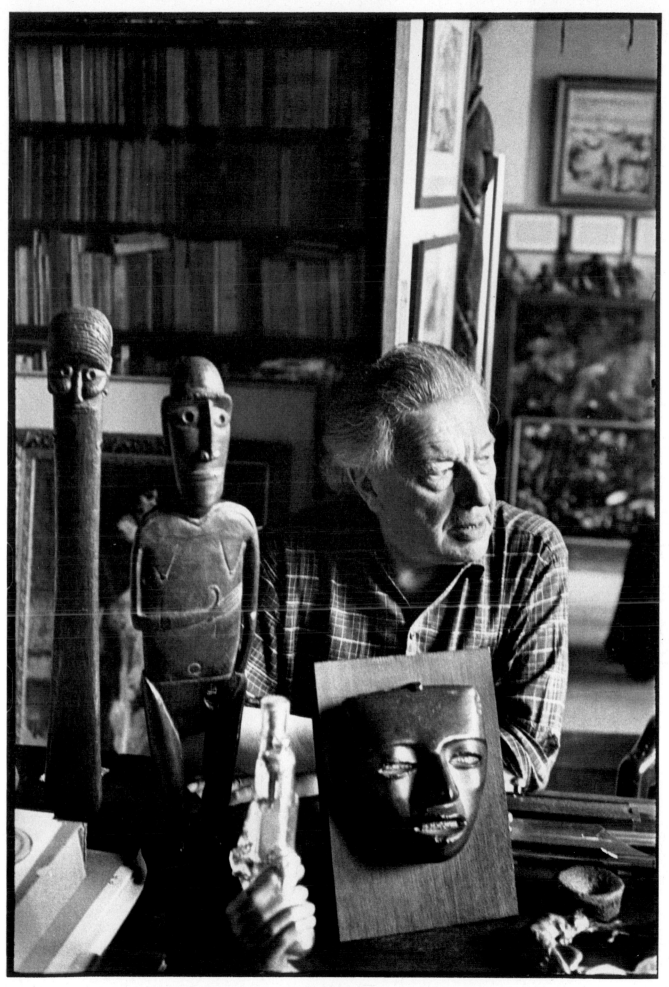

André Breton, 1960

7

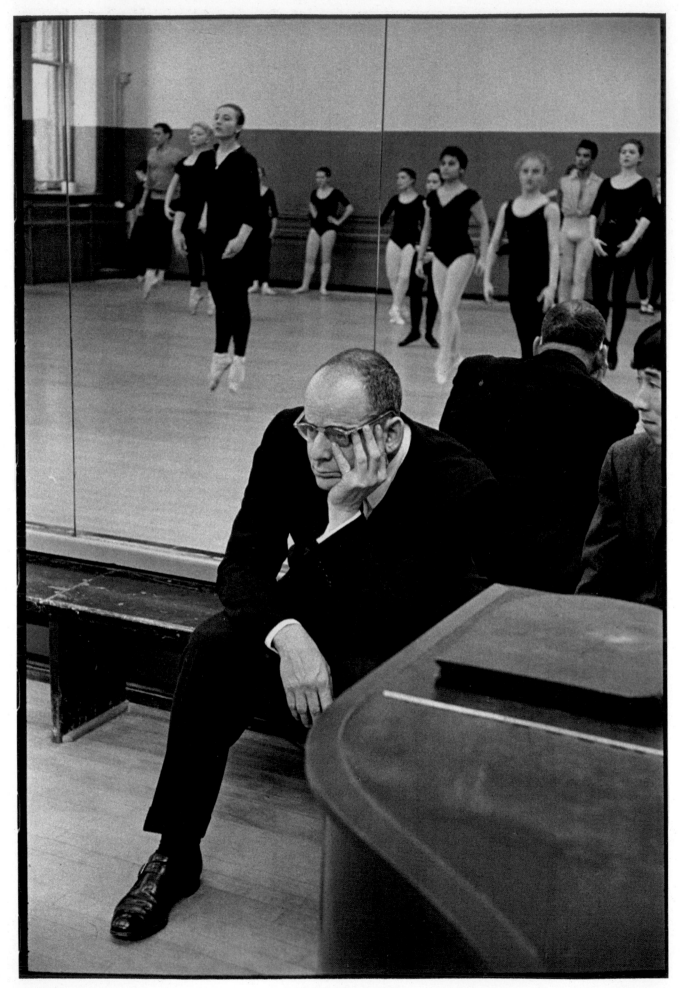

Lincoln Kirstein, 1959

8

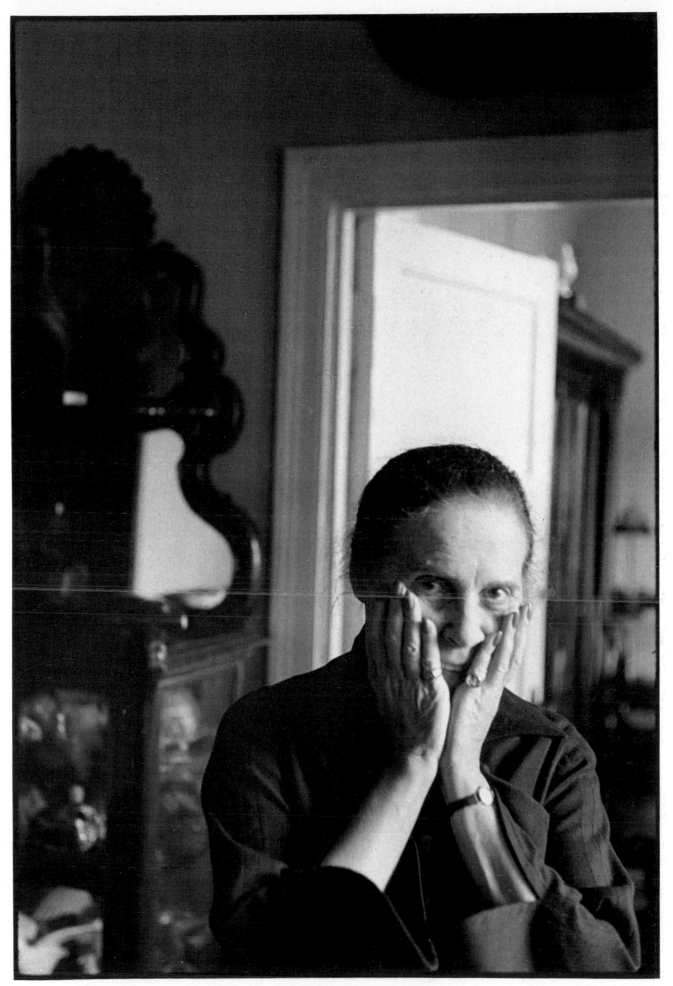

Lili Brick-Maiakovsky, 1954

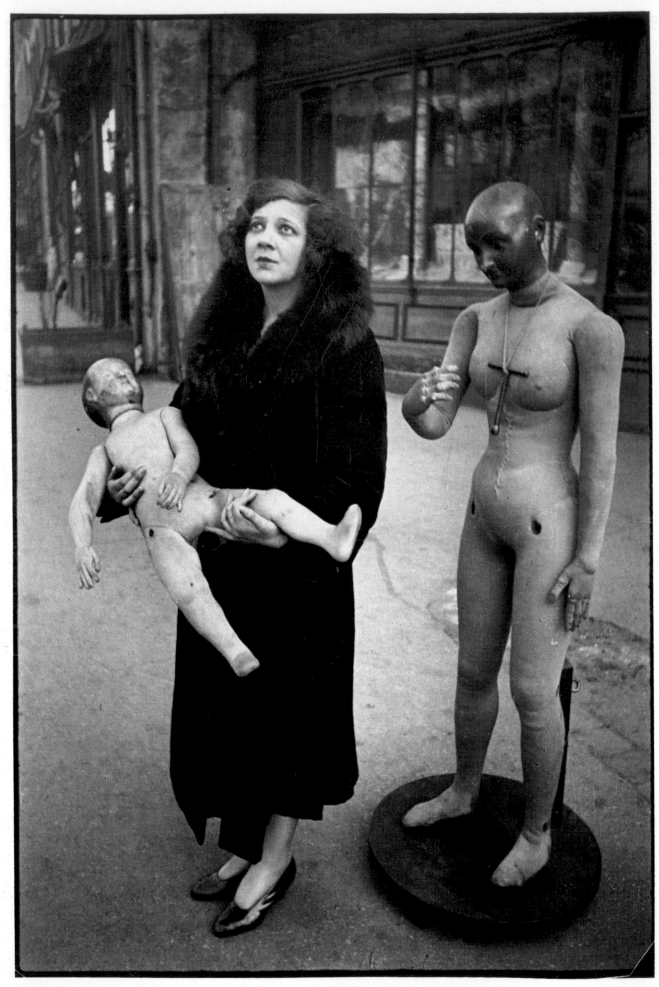

Leonor Fini

10

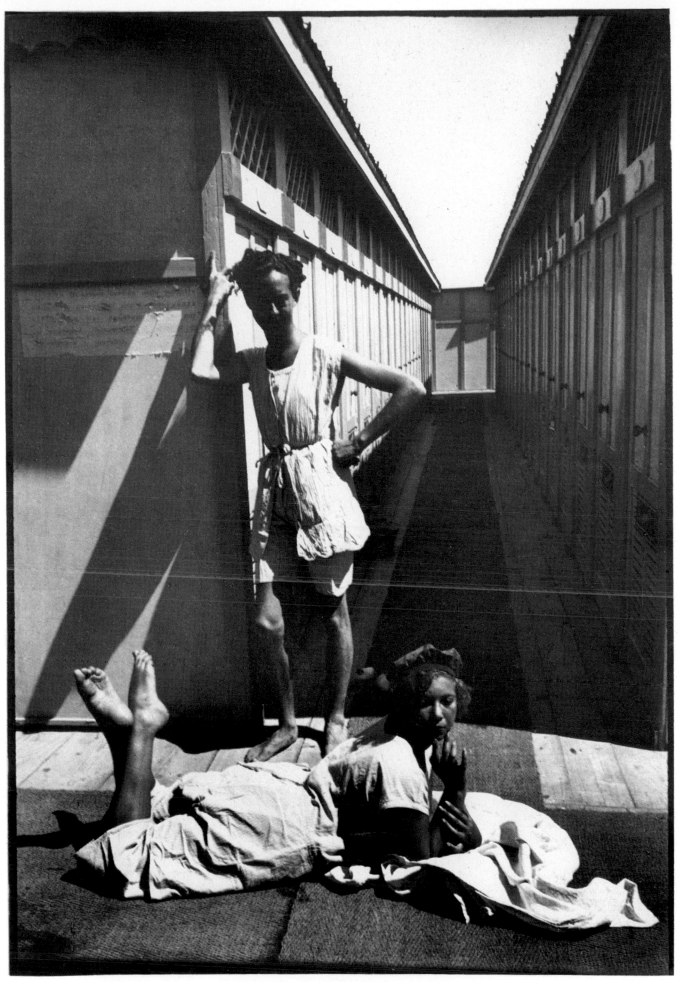

Leonor Fini and André Pieyre de Mandiargues, 1933

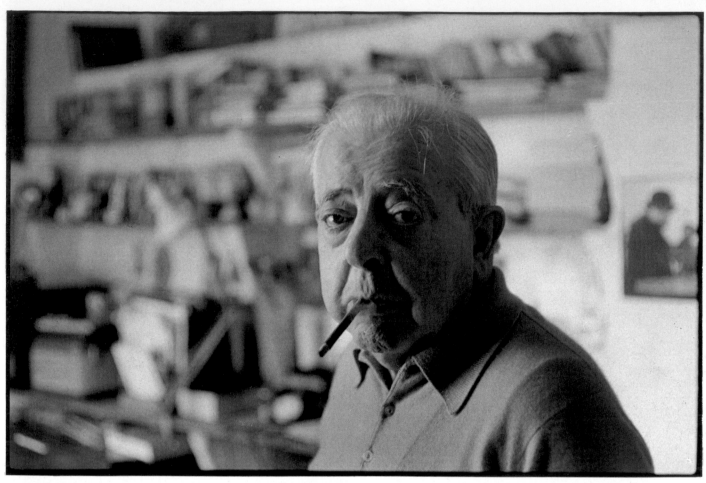

Jacques Prévert, 1973

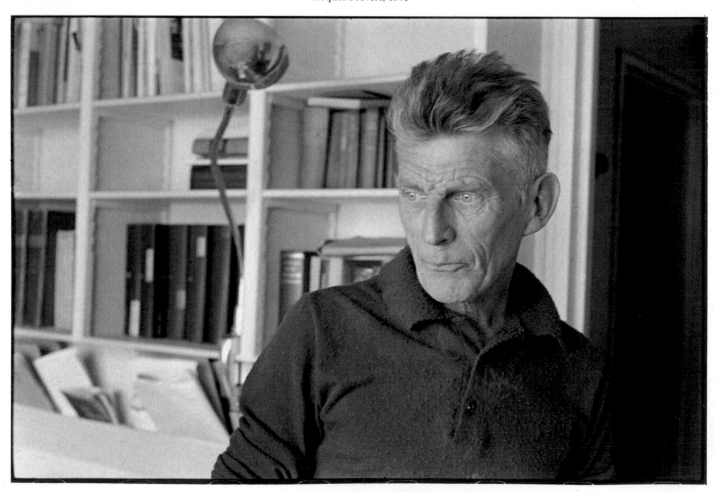

Samuel Beckett, 1965

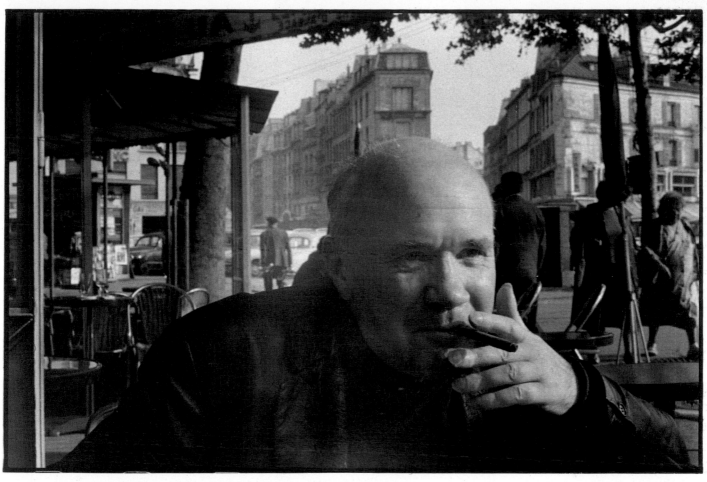

Jean Genet, 1964

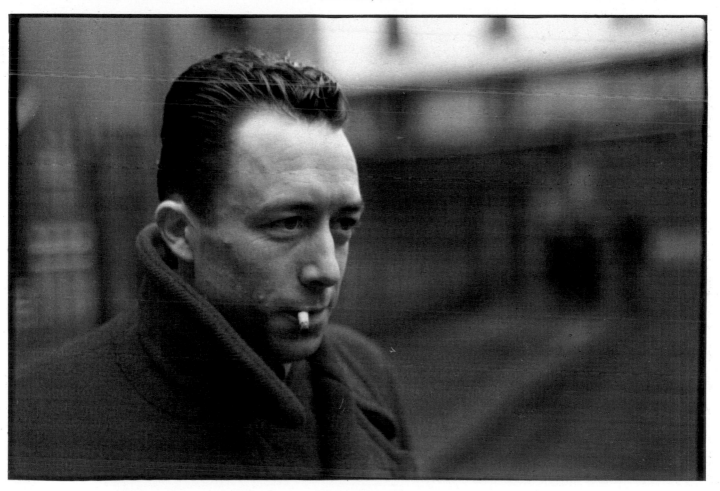

Albert Camus, 1946

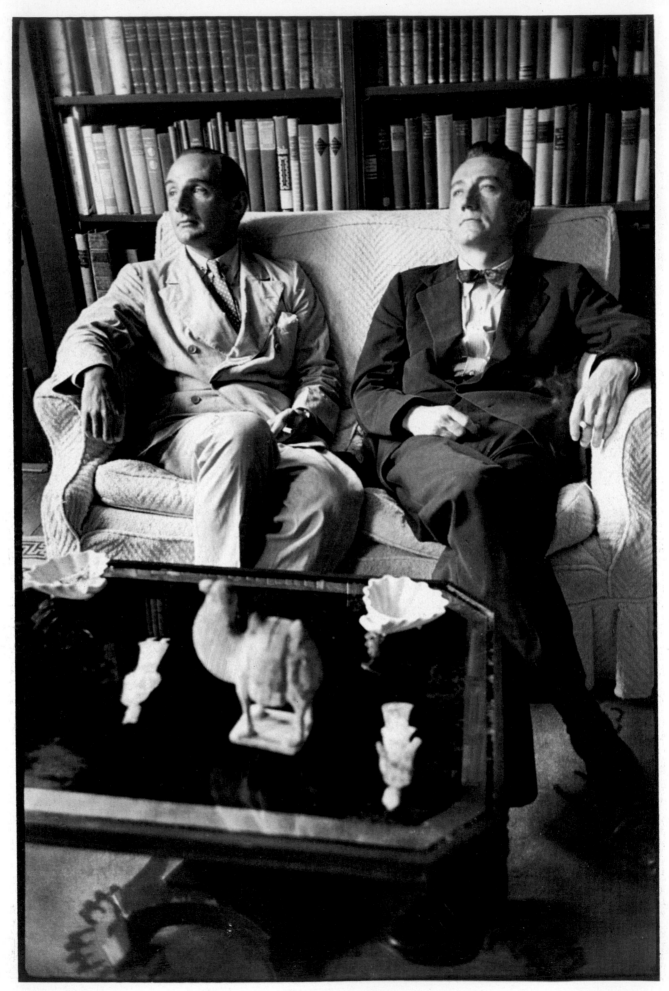

Alstop brothers, 1946

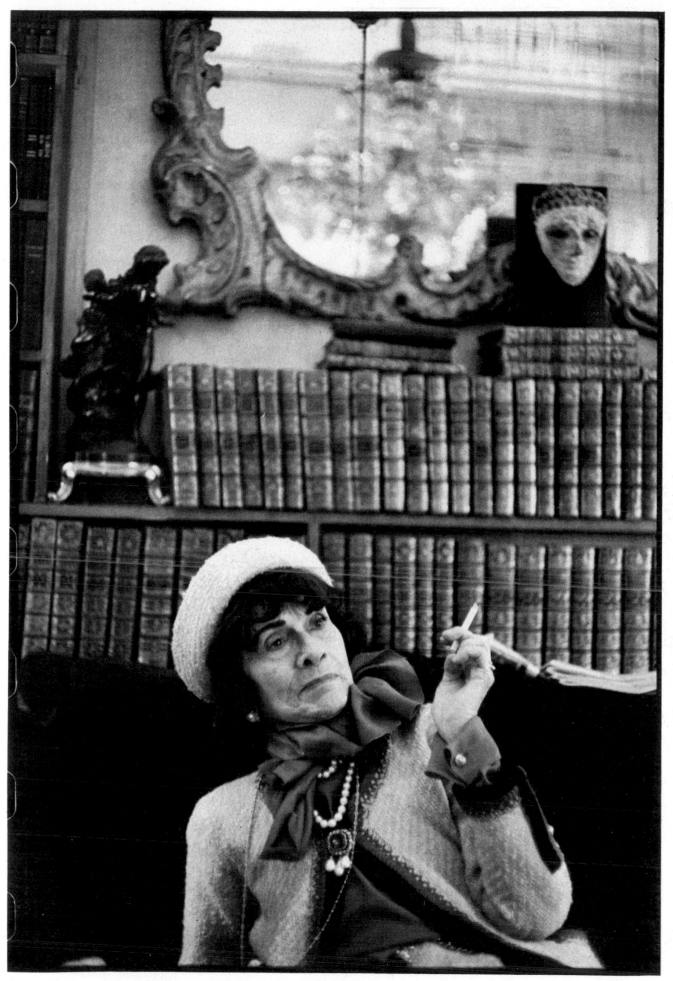

'Coco' Chanel, 1961

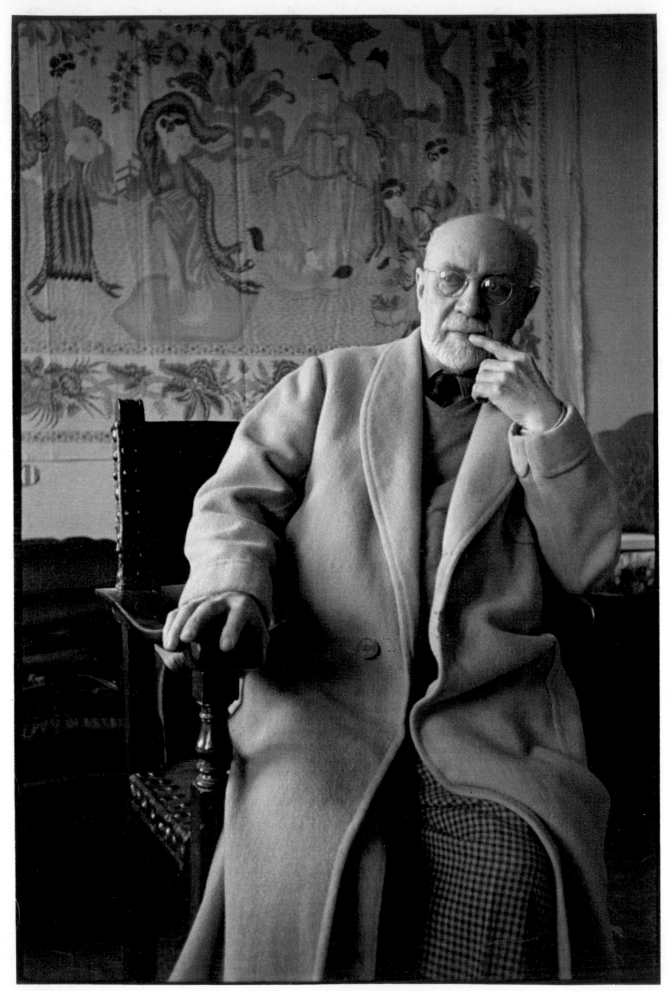

Henri Matisse, 1944

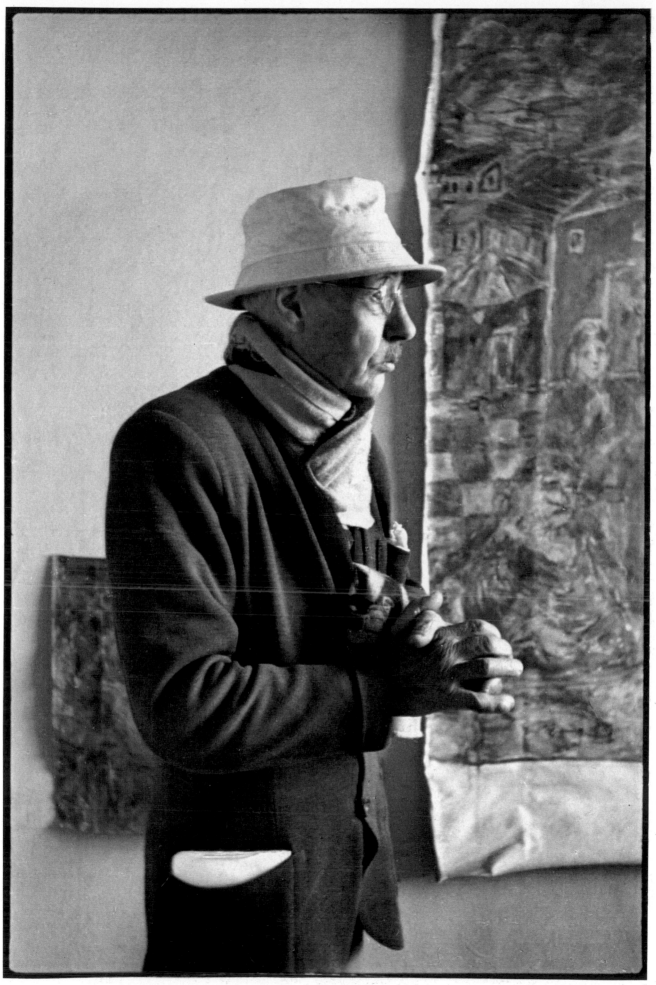

Pierre Bonnard, 1944

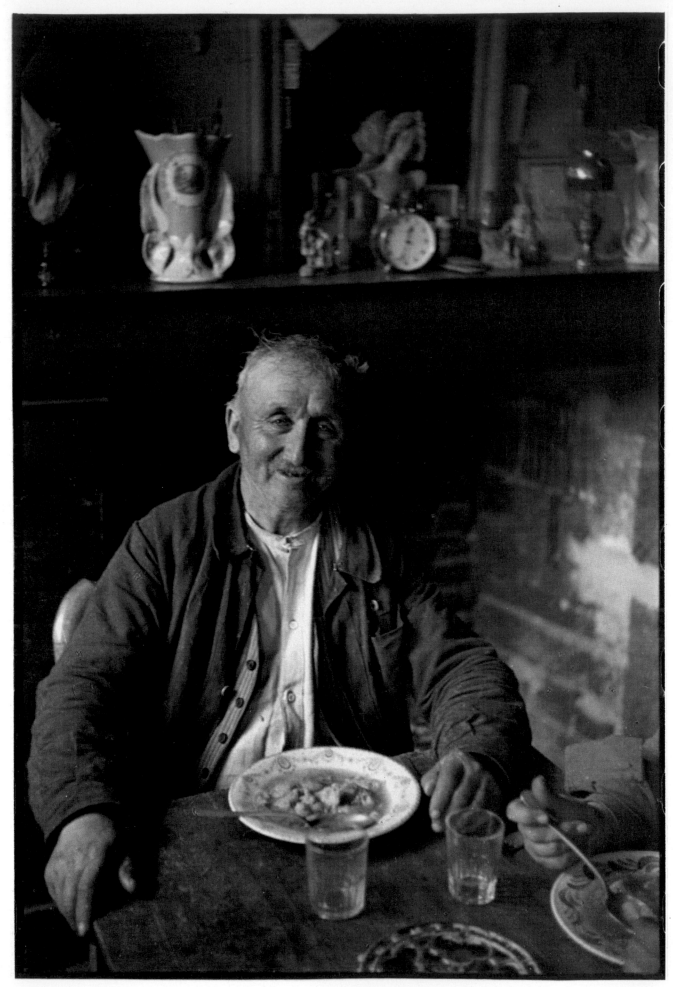

'Flo-Flo', 1944

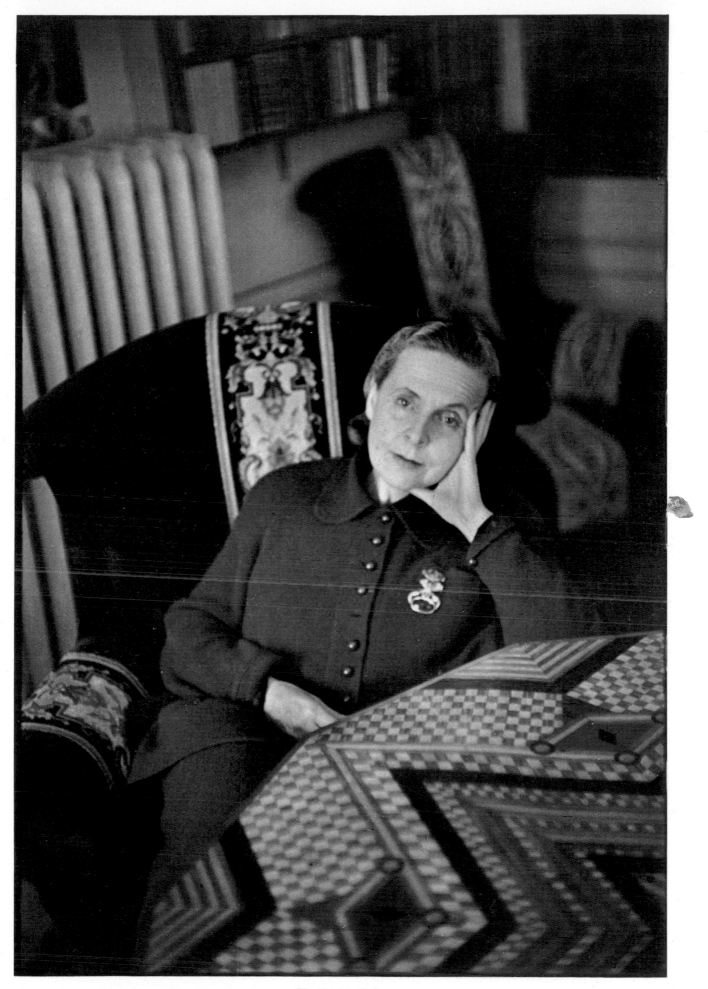

Elsa Triolet, 1945

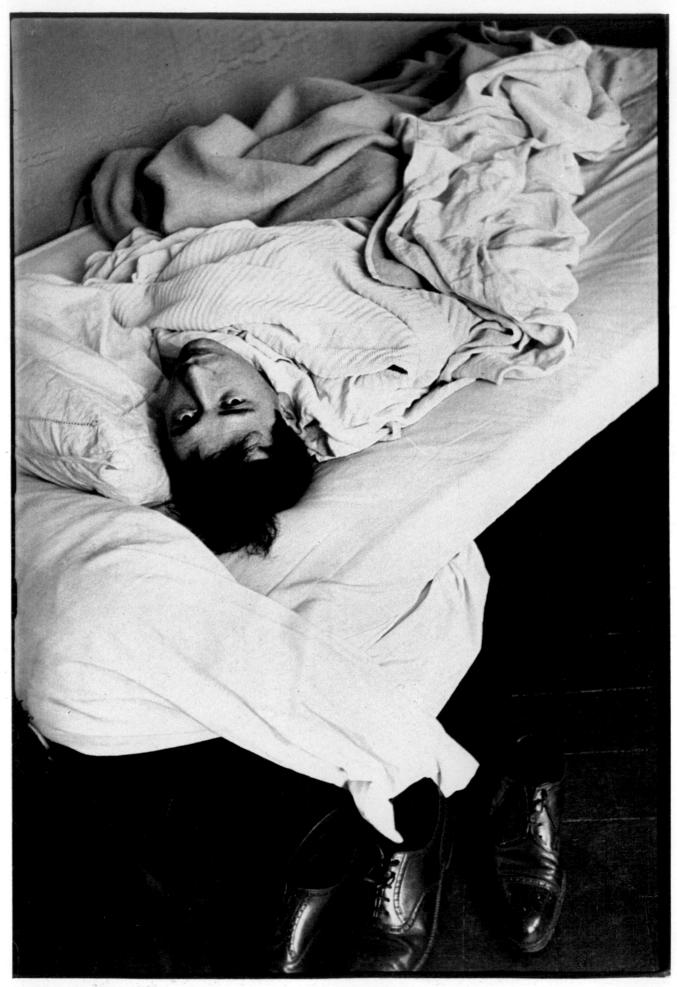

Pierre Colle, 1936

20

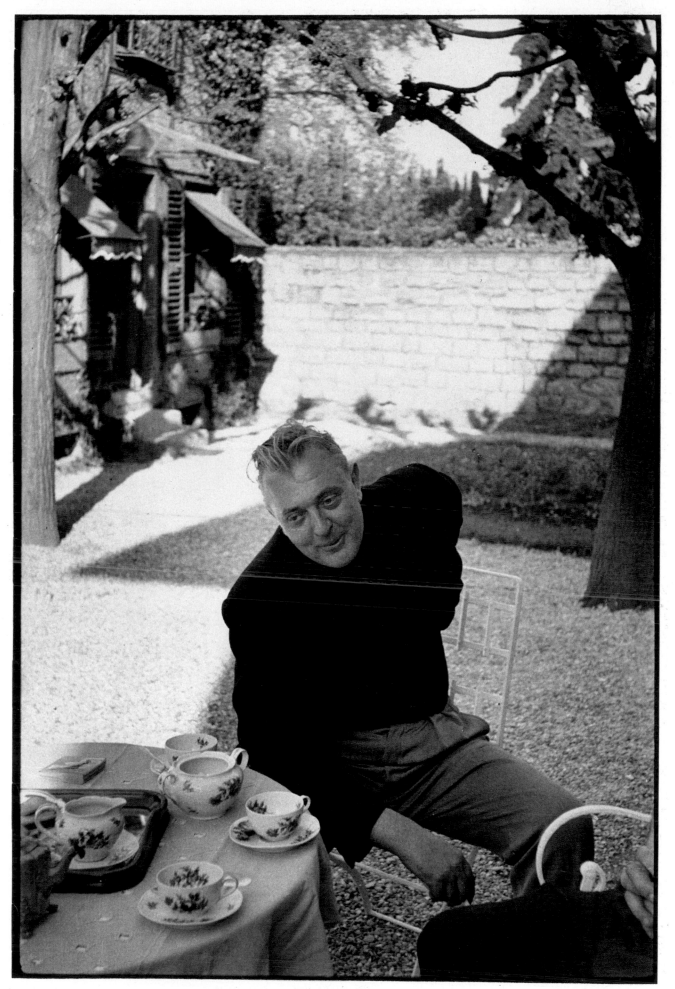

Jacques Tati, 1964

21

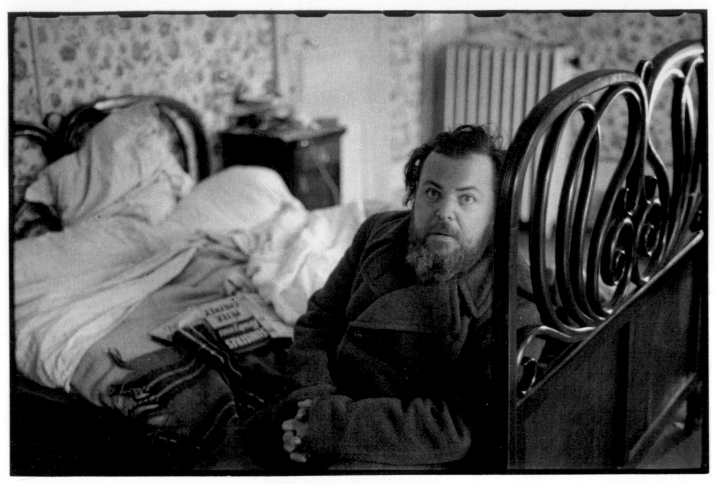

Christian Bérard, 1948

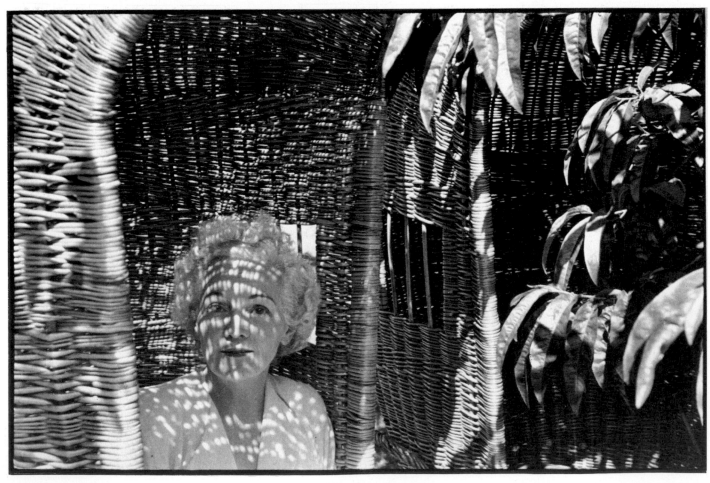

Katherin Ann Porter, 1946

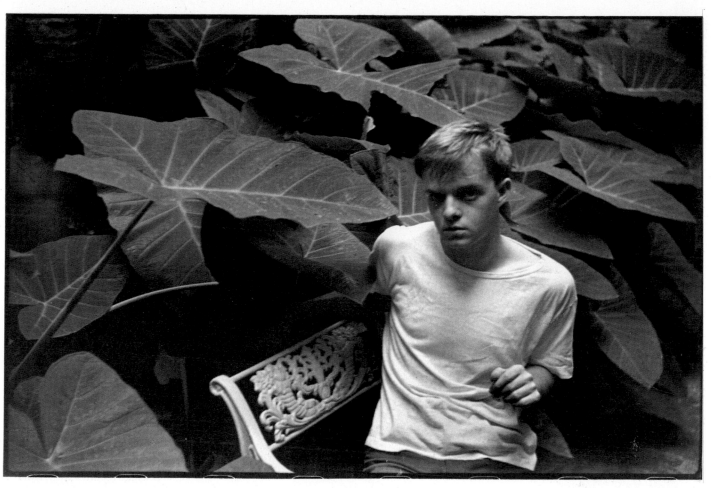

Truman Capote, 1946

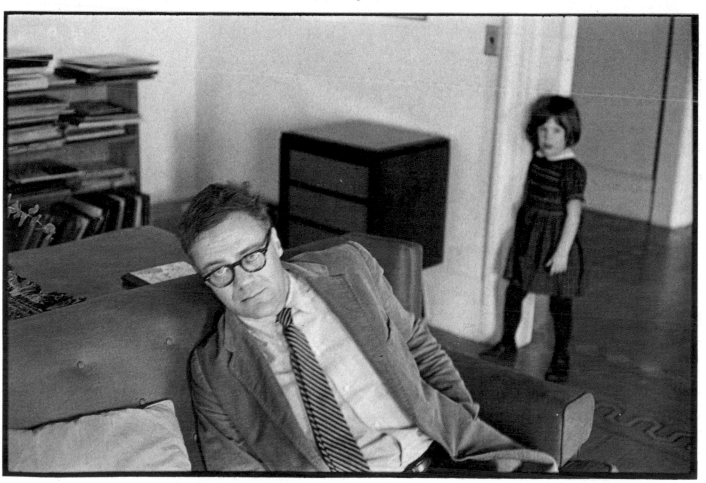

Robert Lowell and his daughter, 1946

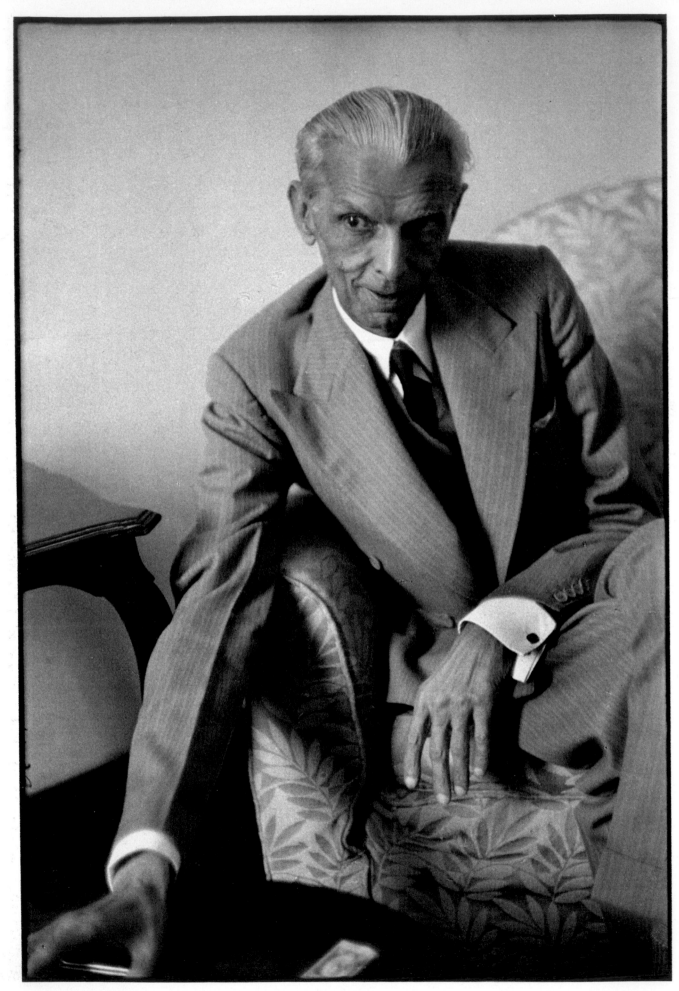

Jinnah, 1949

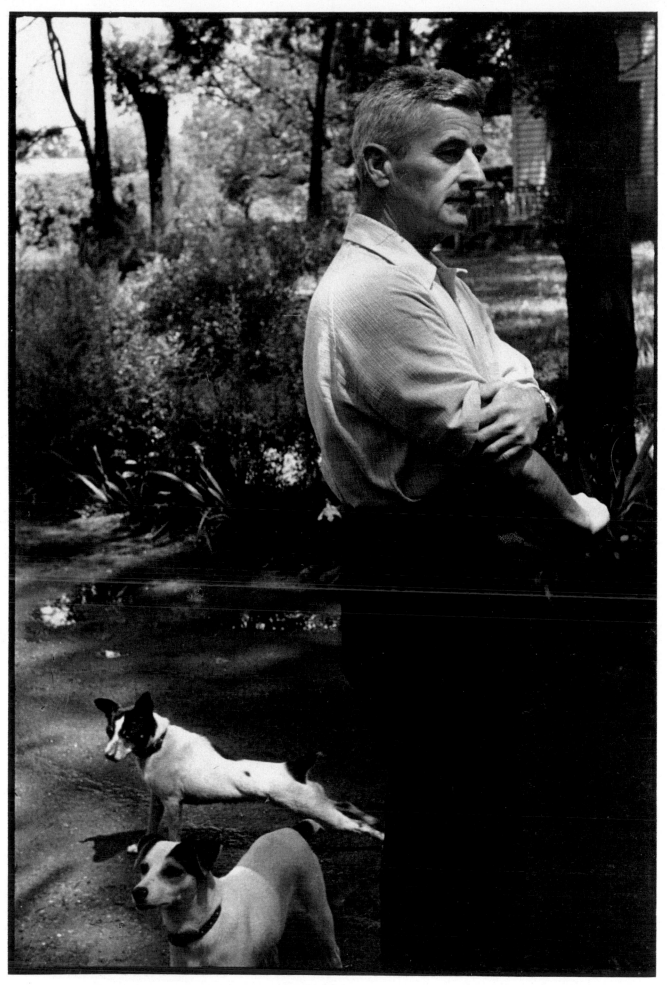

William Faulkner, 1946

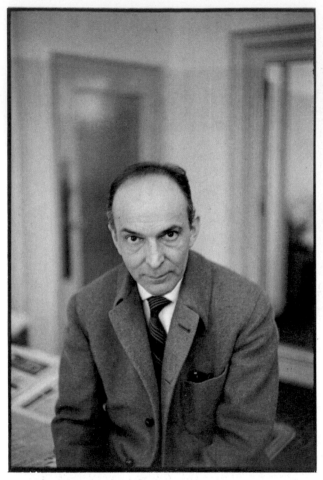

Igor Markevitch, 1962

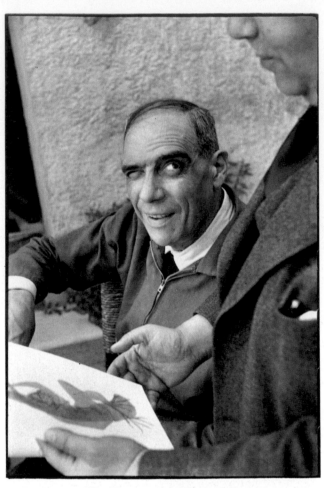

Henri Laurens and Tériade, 1953

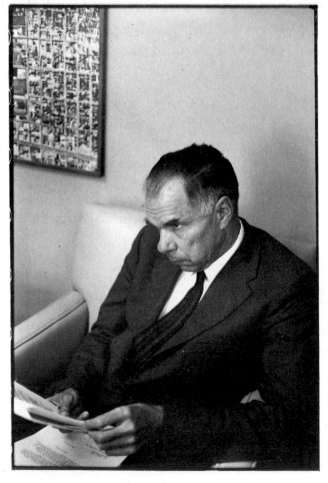

Glenn Seaborg, 1960

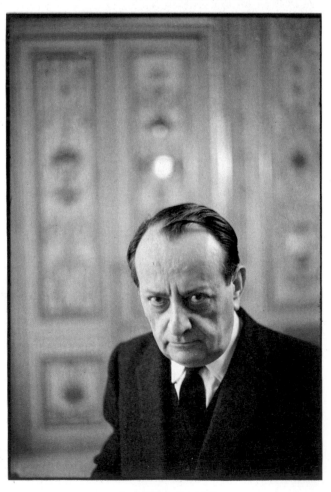

André Malraux, 1969

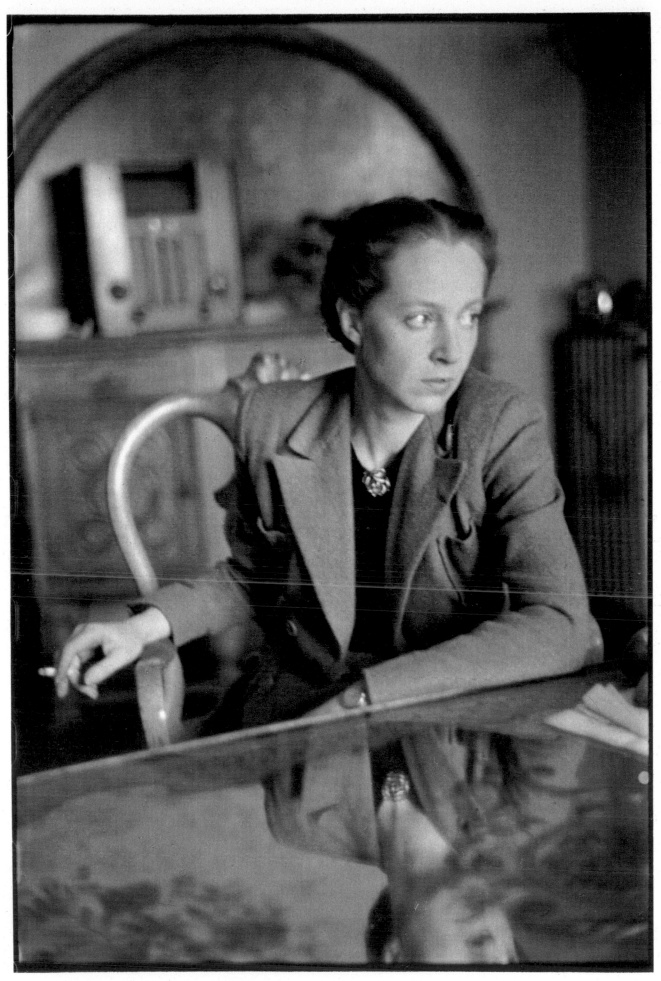

Mara Lucas (Marie-Claude Vaillant Couturier), 1945

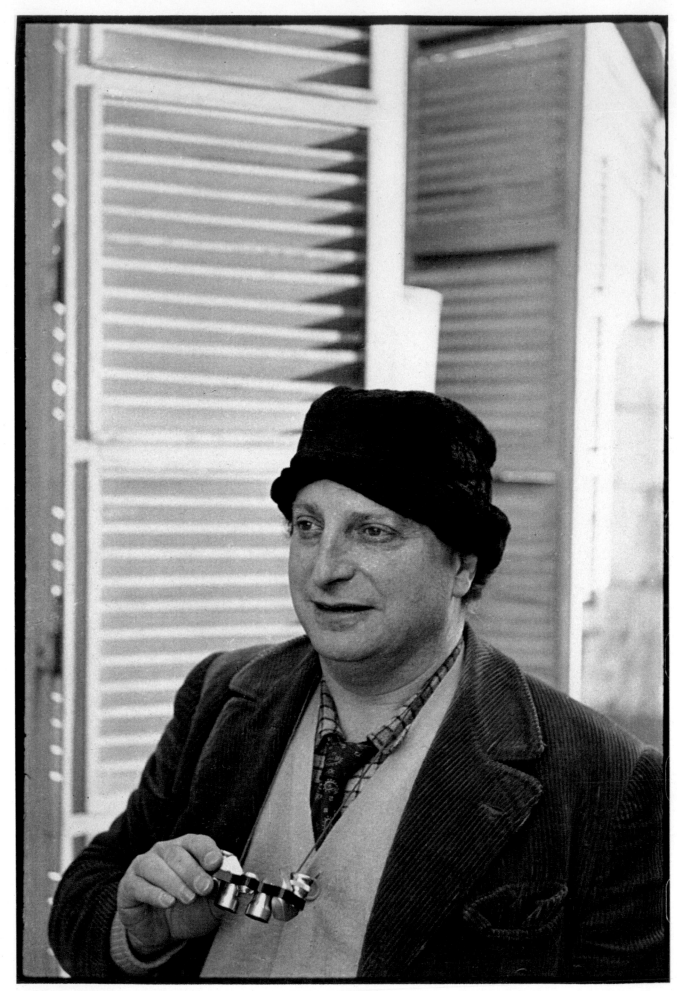

Carlo Levi, c.1952

28

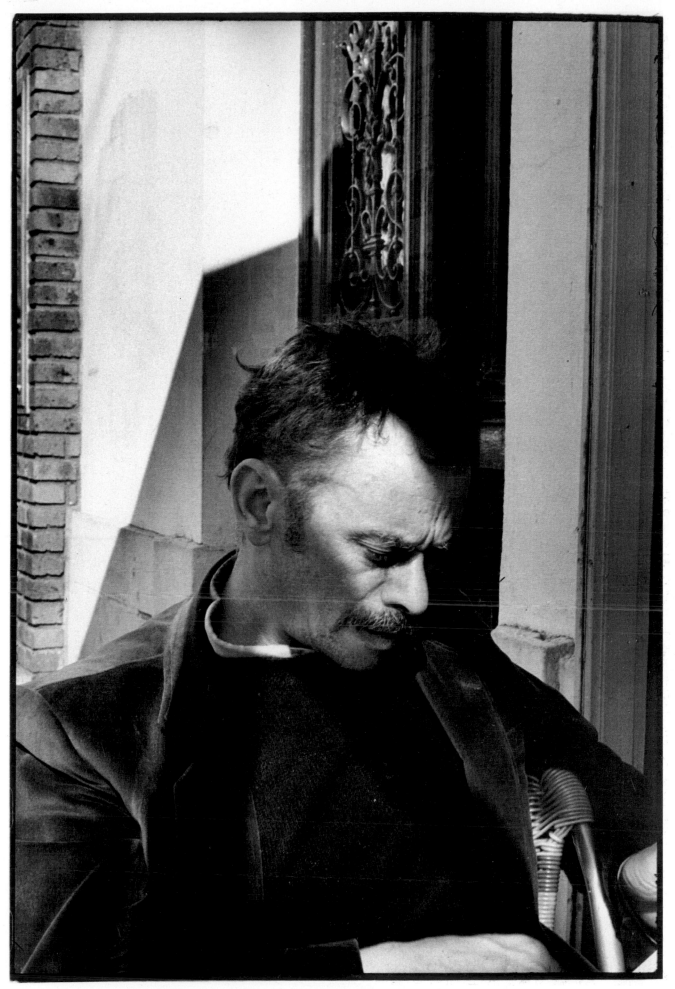

Sam Szafran, 1981

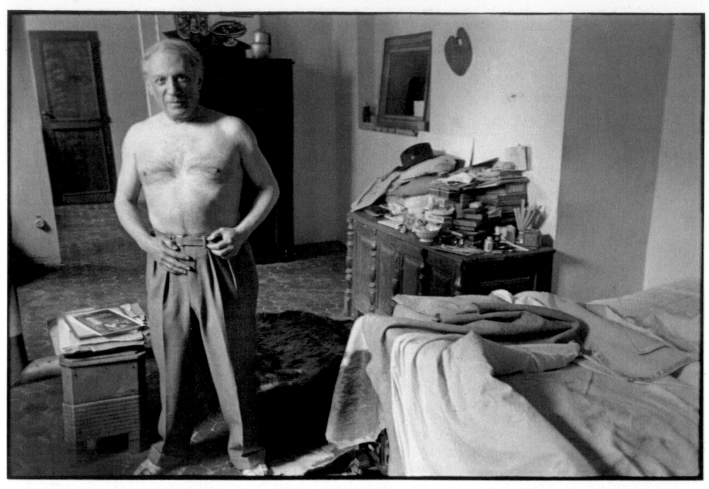

Pablo Picasso, 1946

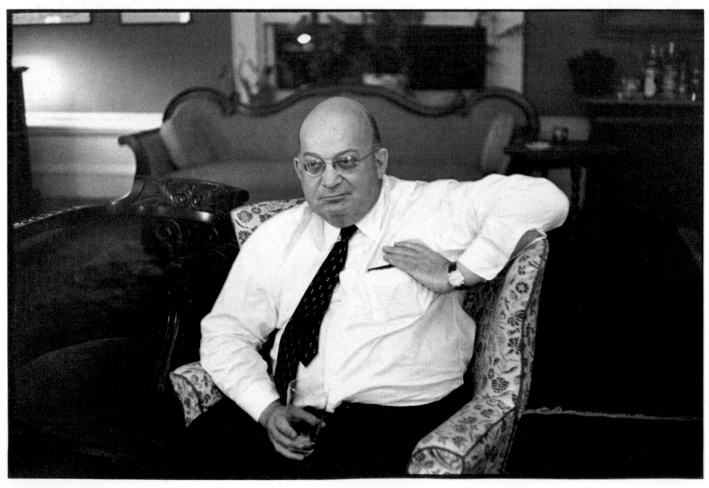

Joe Liebling, 1960

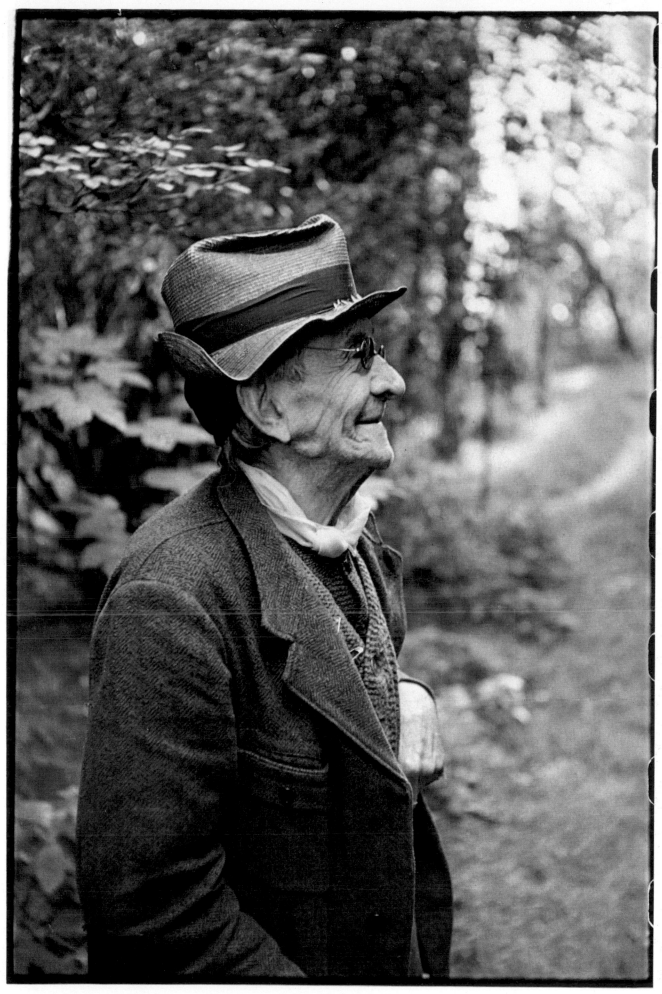

Paul Leautaud, 1952

31

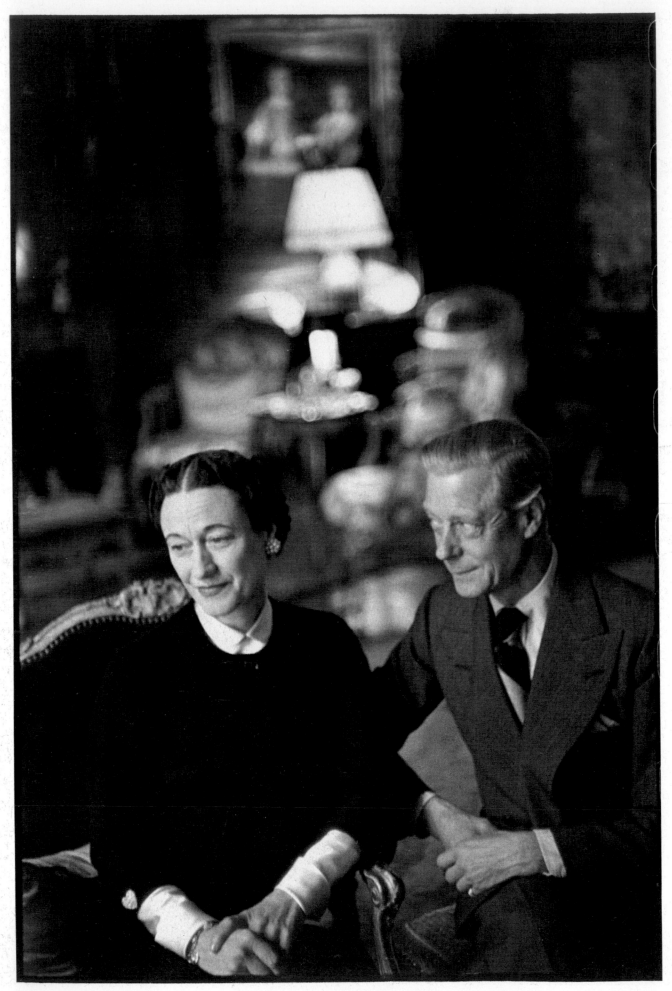

The Duke and Duchess of Windsor, c.1955

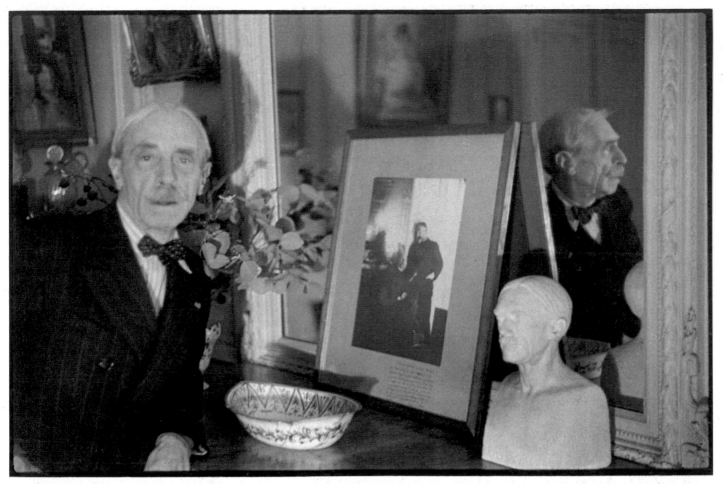

Paul Valéry, 1946

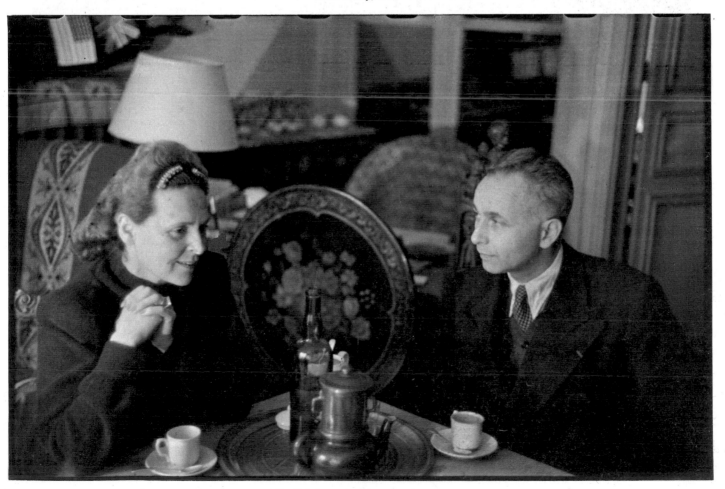

Elsa Triolet and Louis Aragon, 1946

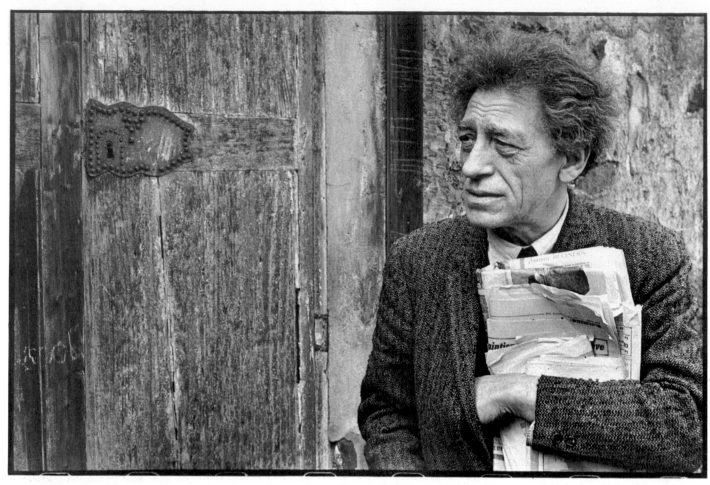

Alberto Giacometti, 1964

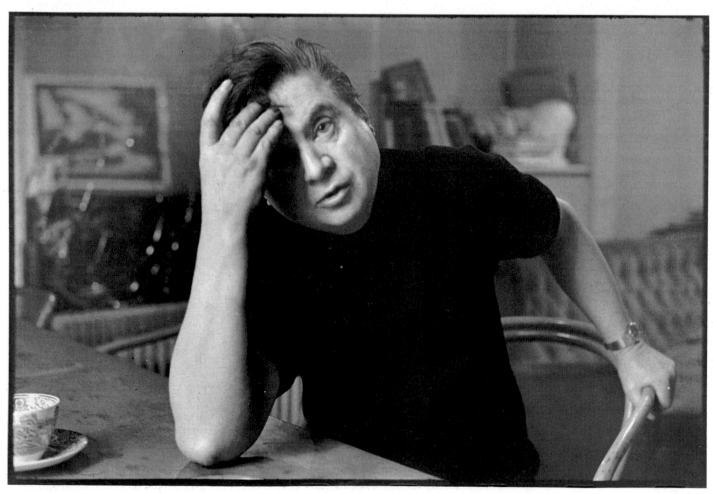

Francis Bacon, 1972

40

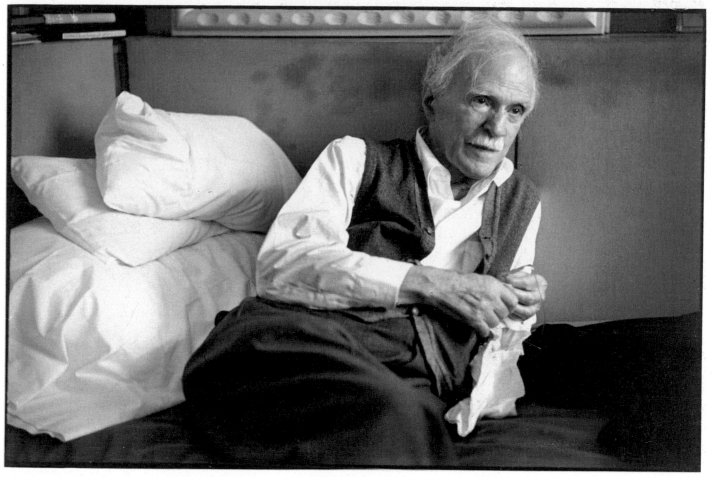

Alfred Stieglitz, 1946

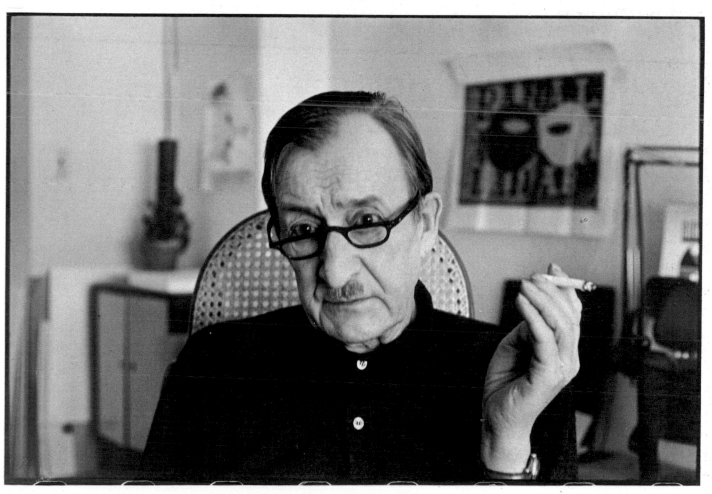

Alexey Brodovitch, 1974

41

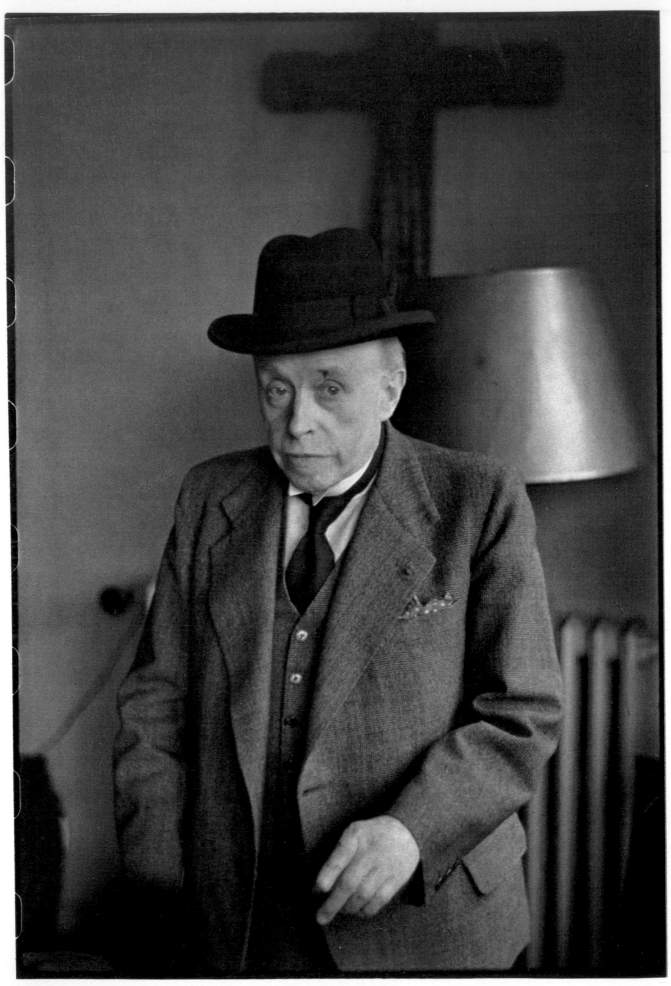

Georges Rouault, 1946

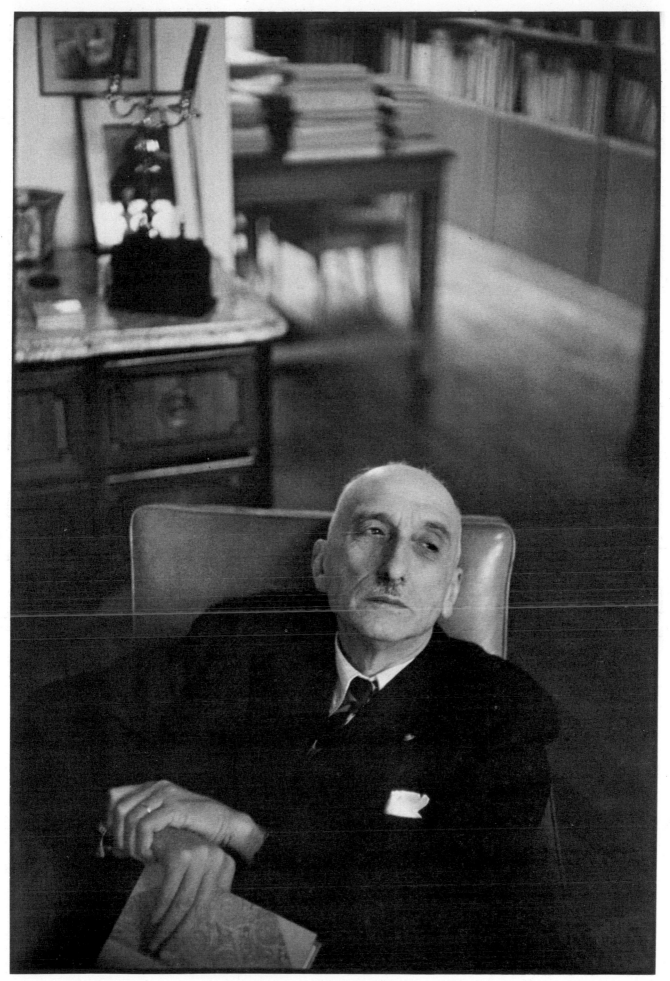

François Mauriac, 1953

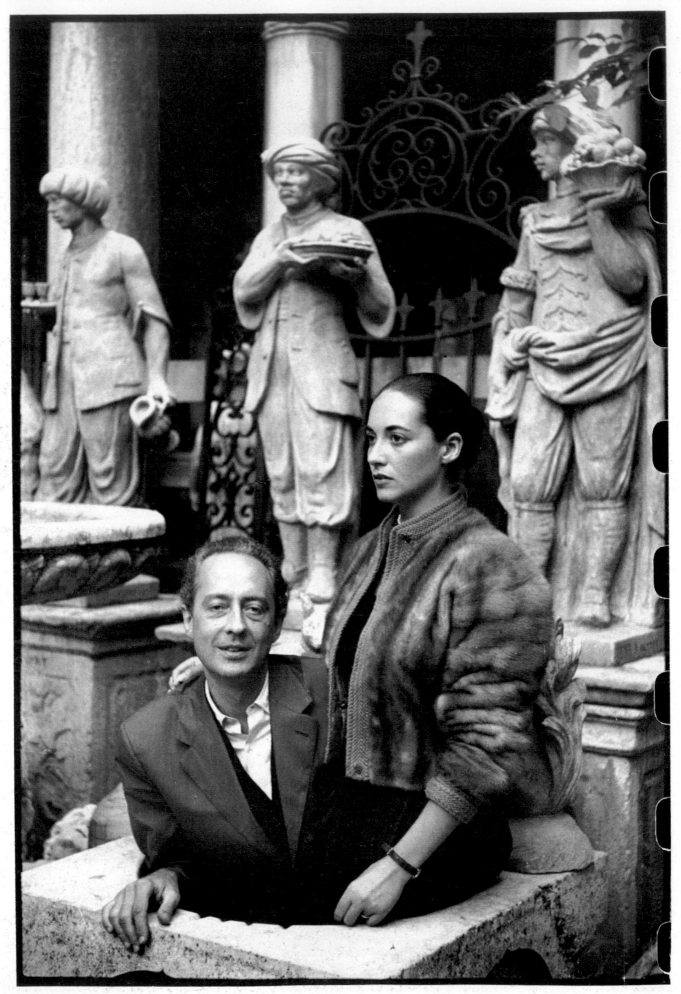

André Pieyre de Mandiargues and Bona, 1972

44

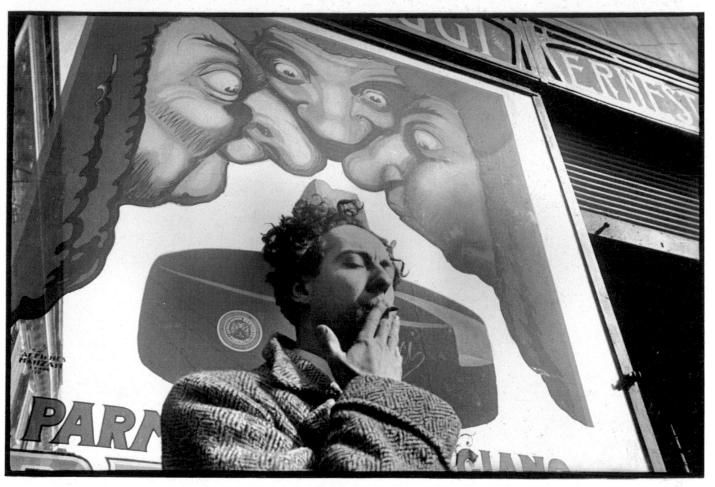

André Pieyre de Mandiargues, 1932

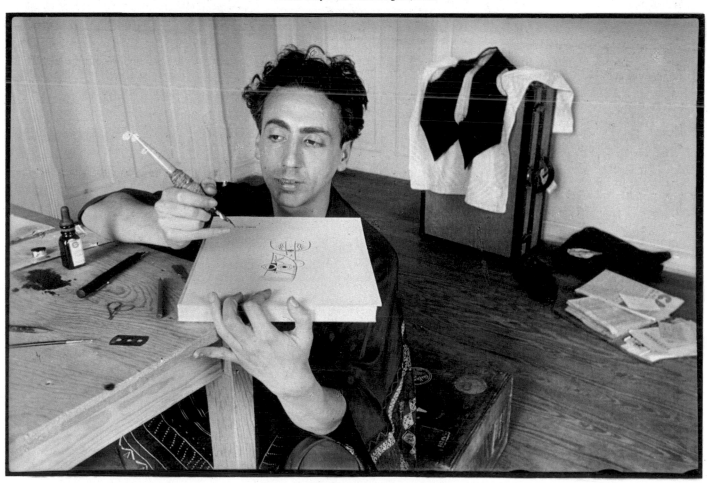

Tonio Salazar, 1934

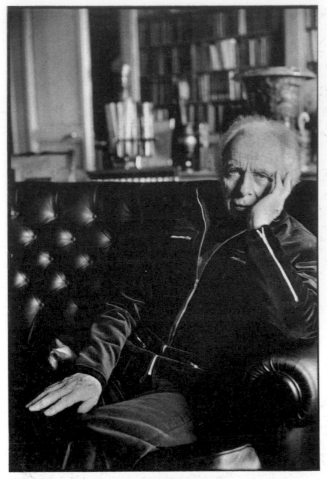

Louis Aragon, 1970

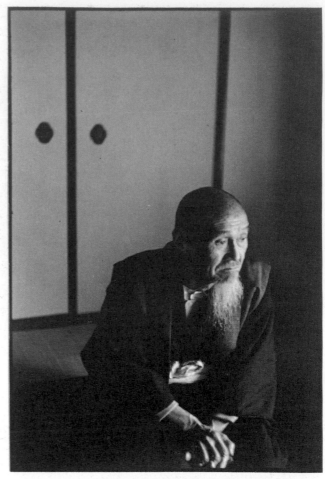

Koen Yamaguchi, 1965

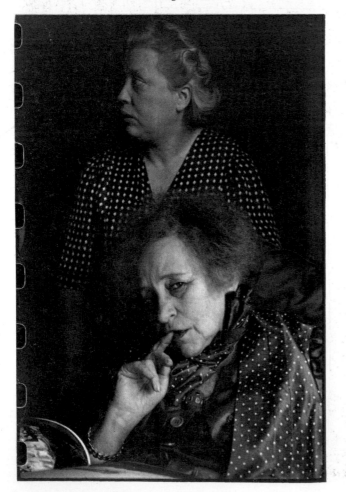

Colette and her maid, 1954

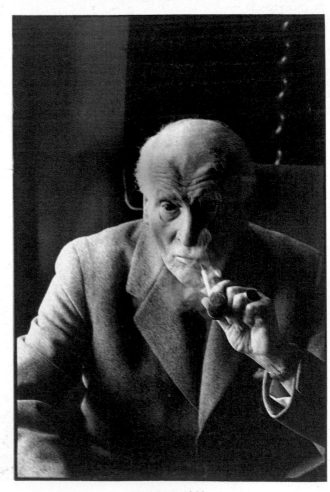

Carl Jung, 1966

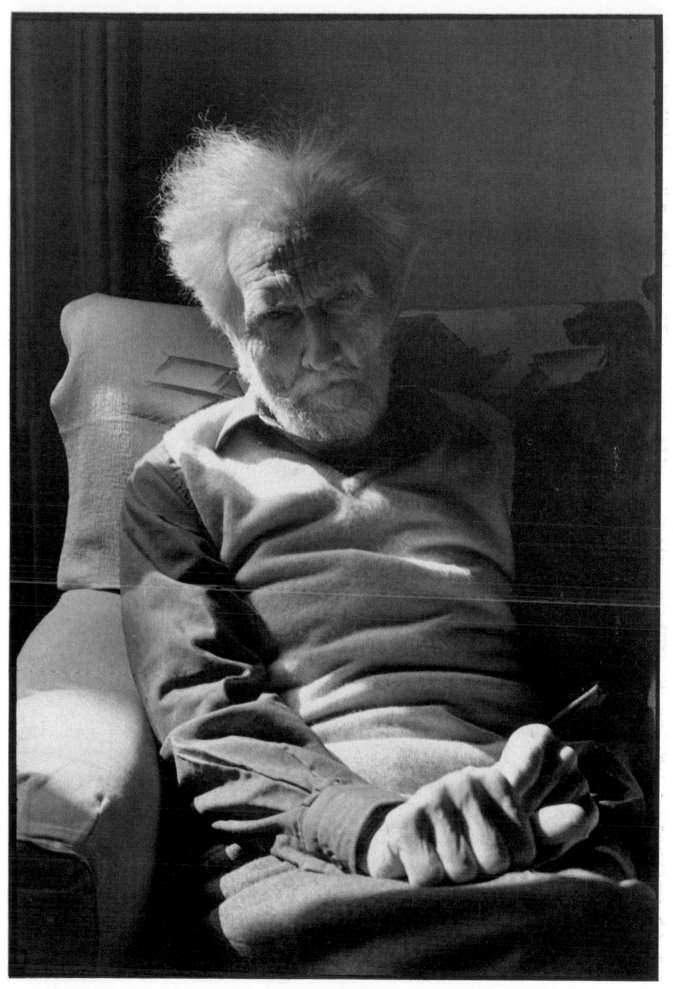

Ezra Pound, 1974

47

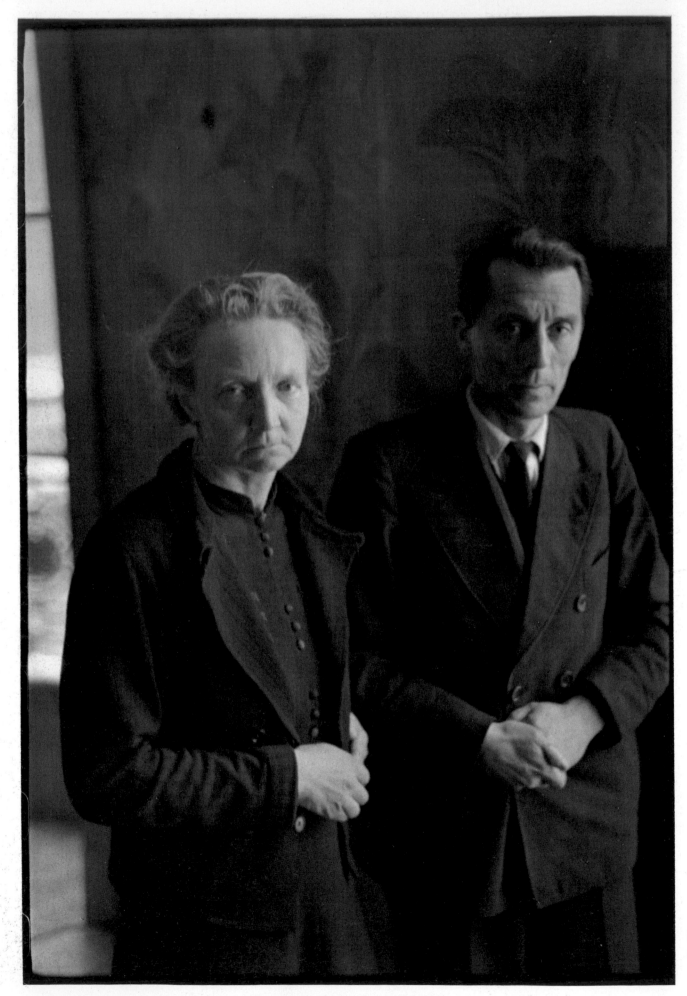

Irène and Jean-Frédéric Joliot-Curie, 1944

48

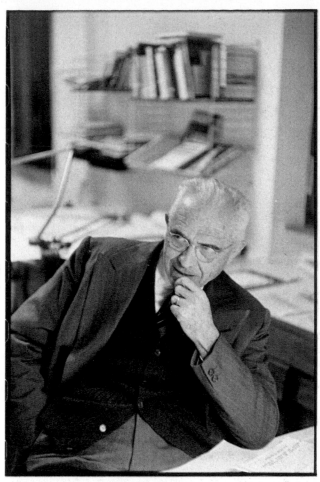

Pier Luigi Nervi, 1965

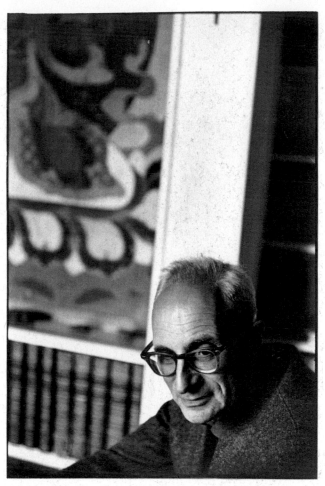

Claude Lévi-Strauss, 1973

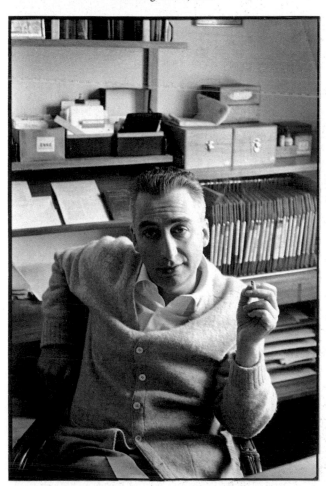

Roland Barthes, 1968

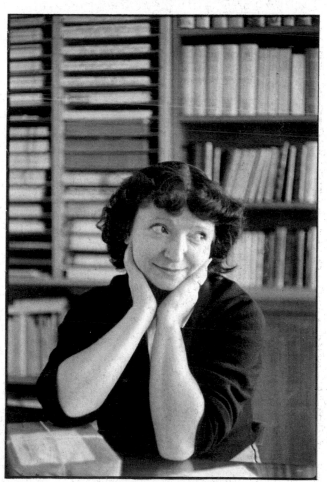

Suziel Bonnet, 1960

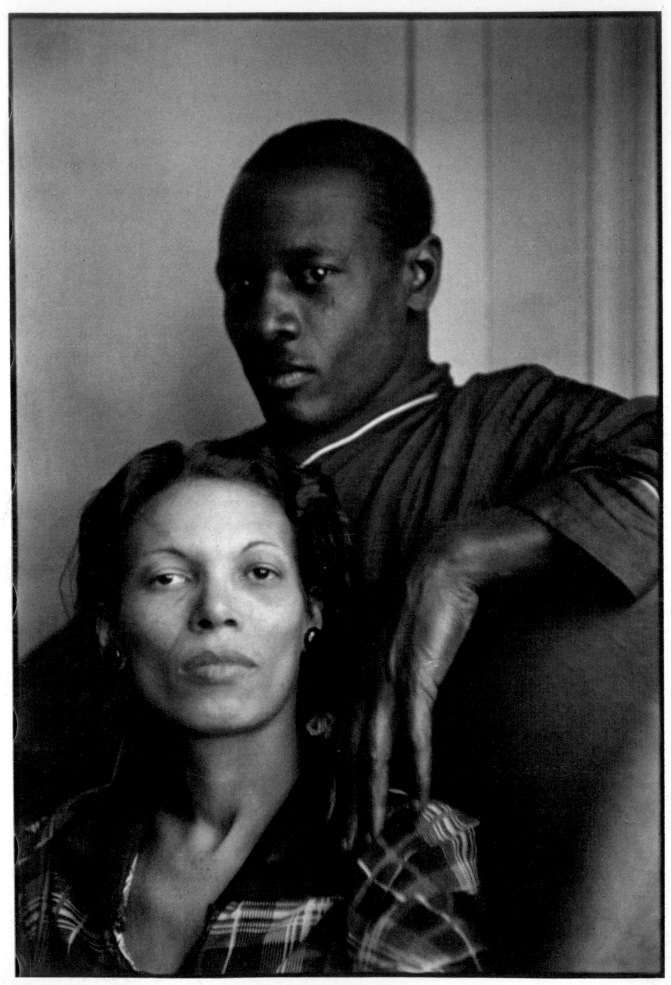

The jazz trombonist Jo and his wife, 1935

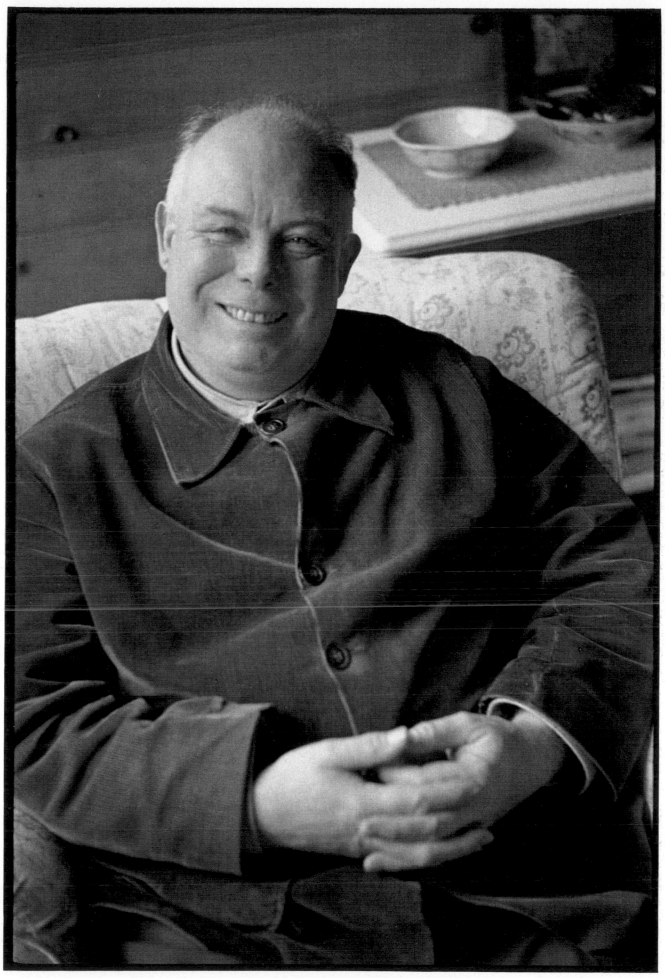

Jean Renoir, 1946

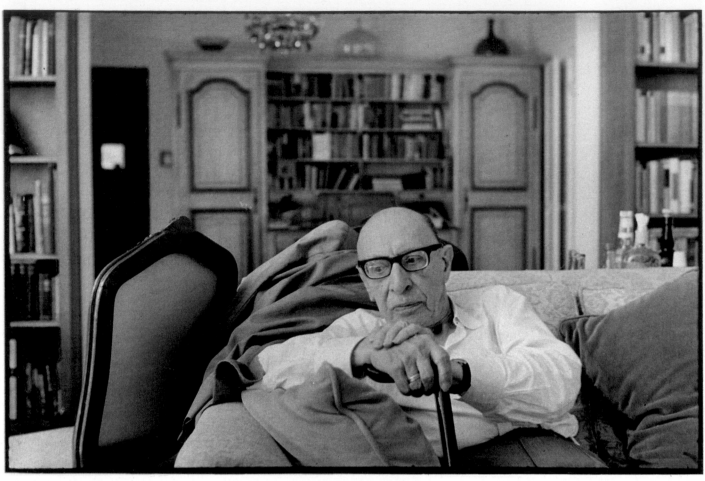

Igor Stravinsky, 1967

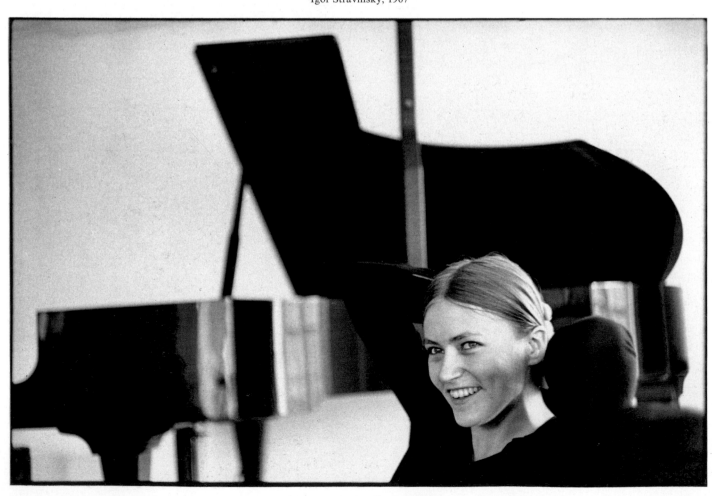

Hortense Cartier-Bresson, 1980

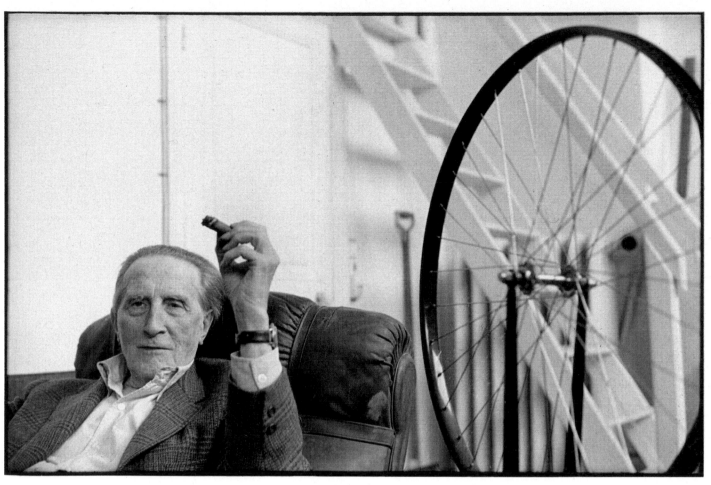

Marcel Duchamp, c.1968

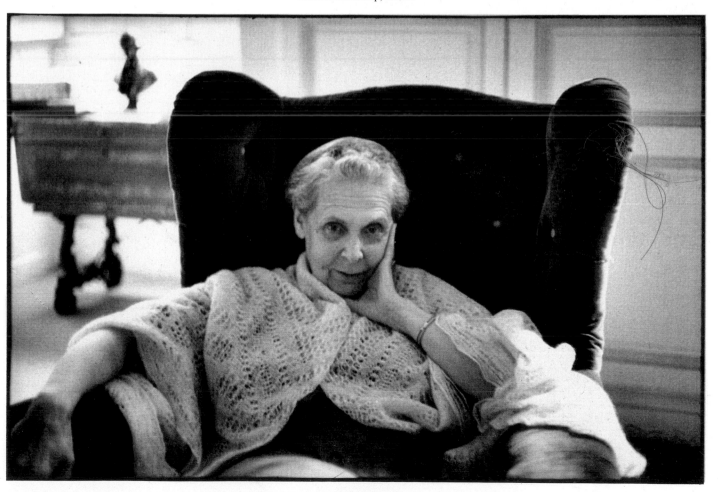

Elsa Triolet, 1964

53

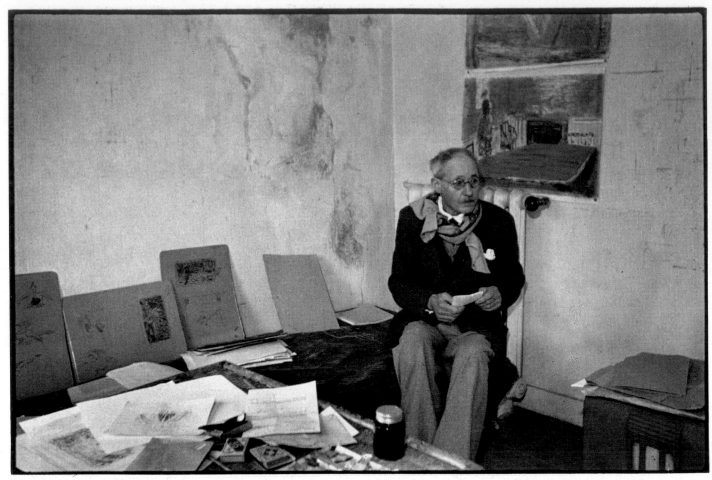

Pierre Bonnard, 1944

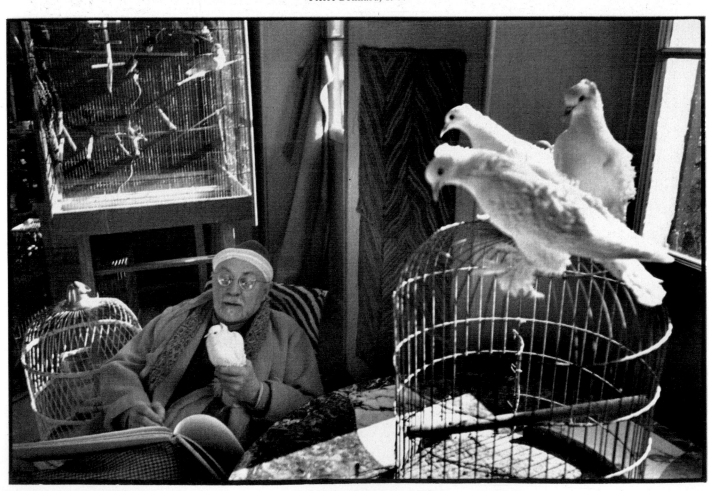

Henri Matisse with his doves, 1944

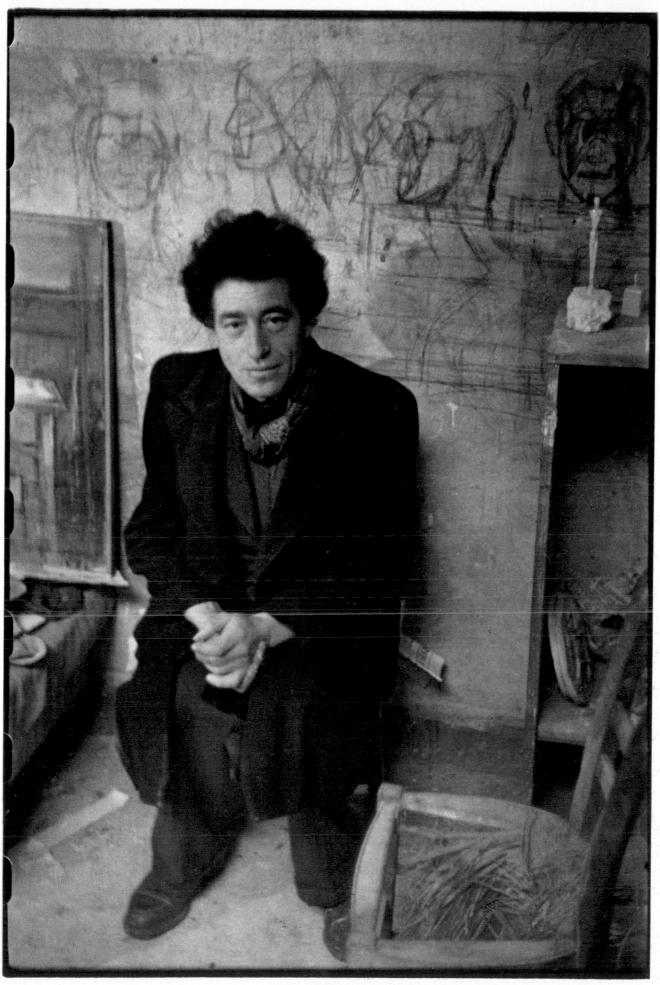

Alberto Giacometti, 1938

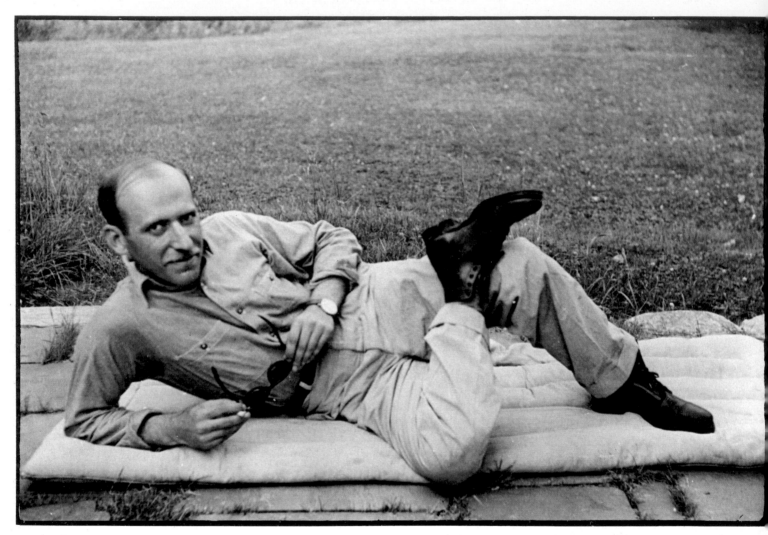

Saul Steinberg, 1946

Conversation without inverted commas with H. C-B.

by Ferdinando Scianna

Being a great photographer does not necessarily imply that one is a great portraitist. In fact, the great photographers in the history of photography who *have* also been great portraitists (and, conversely, the great portraitists who have also been great reporters or landscape photographers) are few in number. Cartier-Bresson is one of the few.

In recent years, however, Henri Cartier-Bresson has concentrated much more on drawing and painting, at the expense of photography. He draws or paints, every day, with humility, with tenacity, with the same passion he puts into everything he does. He claims in so doing to have rediscovered his original vocation and finally closed the 'parenthesis' of photography, a parenthesis which lasted fifty years and the results of which have won him extraordinary world acclaim.

Brought up on Proust, Saint-Simon and Stendhal, Henri Cartier-Bresson is fascinated by people. His relationship with the portrait has always been particularly intense. That, perhaps, is why he wished this volume to be dedicated to a part of his work as a photographer which is so important to him, even if less widely known.

Henri Cartier-Bresson had already written a very illuminating page on his way of conceiving the portrait, in the very famous text his great friend and publisher Tériade persuaded him to write in 1952 as a preface to *Images à la sauvette,* which has been standard reading, *pro* or *contra,* for three generations of photographers now. For this book, however, he wished to add other remarks, other ideas developed over the decades, which have tempered his original views and revealed new, fascinating and often surprising aspects. To do this, he chose the method he prefers—that of a conversation between friends. A conversation, not an interview. It is, in fact, impossible to interview Cartier-Bresson. Statements between inverted commas seem monstrous to him. They prevent one, he says, from contradicting oneself. And contradiction is what Cartier-Bresson is all about. Not because he says contradictory things. But because his very nature is contradictory, impossible to grasp, like mercury, a liquid metal.

When you want to seize hold of it, it breaks up into a thousand droplets, immediately reforming into a compact mass. Henri Cartier-Bresson talks in volleys, accumulates details, turns back, refines an idea, a definition, perpetually on the move. One minute he is kneeling down, the next, up like a shot again, taking hold of a book, quoting a verse by Char, a sentence by Ponge, a definition by Victor Hugo, pursuing his thoughts like an elegant intellectual dance.

One is struck by his speckled blue eyes, like hard stone, which are never still for a moment. His youthfulness, his nervousness are remarkable, almost frightening. This seventy-five year old would wear out a youth.

Here comes the first surprise. The portrait, says Cartier-Bresson, is the opposite of the picture taken *à la sauvette,* in a flash, surreptitiously. To do a portrait, you have to ask for an audience, and obtain it. Then you have to achieve an understanding with the person being photographed, to the point of connivance. A good portrait is the fruit of mutual availability.

Many of his portraits have been taken for publication in books or magazines. I have never had anything, says Cartier-Bresson, against working to order. Some photographers nowadays seem anxious to revive the romantic myth, a little late, of the artist who cannot accept any professional assignment without compromising his freedom. He does not agree. The great artists of the past were perfectly capable of expressing the greatest freedom despite working exclusively to order, if not actually in someone's service. The freedom of the artist, says Cartier-Bresson, is

Statements between inverted commas seem monstrous to Cartier-Bresson. They prevent one, he says, from contradicting oneself.

something else. It is a rigorous frame of reference, within which all manner of variations are possible.

In contrast, he has never done portraits directly for customers. Back in 1952, he spoke of what he saw as the dangers of taking portraits directly to order. Apart from a few benefactors, everyone wants to be flattered and then none of the truth is left. In fact, customers are wary of the objectivity of the camera while the photographer is looking for psychological acuteness. Taking a portrait of a customer, he now confirms, means exposing oneself to the inevitable dissatisfaction caused by comparing the portrait with the picture everyone carries around inside their head of how they look. 'Haven't I come out badly', generally means, 'How different I look from the way I think I am and would like to be'. On the other hand, says Cartier-Bresson, I have always enjoyed photographing friends, which is probably, he adds, the hardest task of all.

Why the hardest? Surely it should be easier to achieve the necessary 'mutual availability' with a friend?

The first impression one has of a face is very often the right one.

Not always, says Cartier-Bresson. In fact—and here is another clue to the way he sees the portrait—the first impression one has of a face is very often the right one, and if it is enriched when we see more of a person, it also becomes harder to express the nature of that person when we get to know them more intimately. He has been convinced of this for thirty years now. When you know a person better, he tells me, you no longer know them well enough.

Does this mean that one can take better portraits of people one does not know at all?

Absolutely not, says Cartier-Bresson. I have always tried to find out as much as possible about the people I have to do portraits of—if they were artists, to read their books, see their pictures, listen to their music, get to know their work, their life history, at any rate.

A fair amount of cultural and intellectual background knowledge is indispensable. Then you must forget it immediately, he adds hastily, just as it is essential to forget yourself in the presence of the person to be photographed and, above all, to get them to forget you and the camera.

How does a portrait session with Henri Cartier-Bresson go? Quite simply. He usually goes to the person's house, or to their place of work, or a place congenial to them. This is very important. If the photographer captures both the internal and external reflections of a world, as he wrote in his preface to *Images à la sauvette,* this happens because people are *in situ.* He must respect the environment, integrate the habitat which defines the social context and, above all, avoid artificiality, which kills human truth. This is why Cartier-Bresson's portraits are never close-ups, nor do they have too much background either, in which the person could get lost. The people are seen at a classic distance, allowing one to converse with the subject and view them through a 'normal' 50mm lens, which also includes their surroundings.

You must try, says Cartier-Bresson, to place yourself immediately in the most favourable position as far as lighting is concerned. In fact, it has never been possible for him to tell someone to move afterwards because the light is wrong. This would be tantamount to killing the human truth of the meeting. But beware! Truth does not mean 'spontaneity' with which it is so often confused and which is in fact mere superficiality. Down with spontaneity, says Cartier-Bresson cheerfully. Long live fulmination. The stroke of lightning which is so specific to photography and so basic to the work of this great photographer.

58

The difficulty, continues Cartier-Bresson, lies in the fact that you must talk, listen and—while keeping your eye glued to the camera—continue looking, or rather, seeing. What is more fugitive than an expression, than that mysterious harmony in the dissymetry of every face, a 'decisive moment' like none other, which if you know how to capture it, becomes a portrait? The thing that strikes him is the ability the viewfinder of a camera seems to have to undress people, to X-ray them and reveal the arrogant, the narcissistic, the shy and so on. It is up to the photographer, as an amateur psychologist, to adapt his behaviour to the nature of the subject. With shy people, the technique Cartier-Bresson has some-times used—with Bonnard, for example—is to say that he has finished after a few shots, that the portrait has been taken, and to go on chatting until the object of the meeting has been forgotten, trust returns and the sitting can be resumed as if by chance.

Cartier-Bresson usually arrives at an appointment with his camera loaded with fresh film. If after the 36 exposures have been used up he still hasn't got his portrait, he says there is no point in continuing. It won't happen. The mere operation of reloading the camera would only reinforce the barrier separating the photographer from his subject, making it even harder to achieve the essential availability. Therefore it is better to desist.

How long does it take to do a portrait? Simone de Beauvoir once asked Cartier-Bresson the same question—a sign of the mutual embarrassment between two people meeting each other a quarter of a century after the photographer had taken a first portrait of the authoress. A little longer than at the dentist's and a little less than at the psychoanalyst's was his answer, because there is no answer, no hard-and-fast rule, just as there is no answer to the classic question his subjects ask: What must I do? Nothing, one could perhaps say, or: be yourself. A tall order.

Naturally, says Cartier-Bresson, the portrait is not a systematic pose. What I might call rules are purely my rules, the instruments I use to make my work enjoyable. And to enjoy his work, it is absolutely essential with Cartier-Bresson for everything to take place without any 'violence' whatsoever.

He is fully aware that the subject is to some extent the victim of the photographer at a sitting. The click of the shutter, he says, is like an insect sting. You have to reach the subject 'between his shirt and skin', in a moment of inner silence, as lightly as possible, so that he can scarcely feel it, so that the sting is as painless as possible. But you cannot persist for too long without transforming the dialogue into torture. Does the photographer know instinctively when he has taken a good portrait? Yes, says Cartier-Bresson. But, he adds, the miracle can happen in the first instant of the meeting or after a long development process.

The click of the shutter, he says, is like an insect sting.

With the Joliot-Curie's, Cartier-Bresson recalls, it was all over in a flash. I opened the door and saw them there, together, exactly as they should be. I shot the photograph (page 48) immediately, even before greeting them, like a stroke of lightning. It was all over. If I stayed, pretending to continue my work, it was only out of politeness.

With Ezra Pound (page 47), the exact opposite occurred. We stayed there for more than an hour-and-a-half. I was crouched in front of him and we looked each other in the eye without saying a word, without any impatience on either side. He stroked his hands. It was another rhythm, another way of seeking harmony. Every now and then I took a photograph. Very few. I must have taken about eight in all.

Henri Cartier-Bresson has taken photographs of many famous people. Tériade,

Technical note

All Henri Cartier-Bresson's photographs have been taken with a Leica rangefinder 35mm camera and most of them with a 50mm lens, though very occasionally he has used a 35mm wide-angle or a 90mm telephoto. He uses only a 50mm lens for portraits.

He composes rigorously for the full frame and he will not allow his prints, enlarged from the whole negative, to be cropped for exhibition or publication in books.

His greatest work is exclusively black and white and he has photographed only very rarely in colour, notably for his book *Vive la France* (1970).

his friend, says that there is a certain ambiguity in his portraits of celebrities, due to the relationship which is inevitably established between the image of their face and the public image created by what they have done. But Cartier-Bresson's portraits do not include any politicians [with the possible exception of André Malraux (page 26)]. Perhaps, he says, because they are all basically the same to me, in their unaccountable relationship with power. Not that the poet or artist wields no power, but theirs is undoubtedly a lot less dangerous than the power exercised by politicians. However, Cartier-Bresson has taken and still takes many portraits of people untouched by celebrity, but no less dear to him for that—country people, in particular, with whom he has longstanding ties, whom he knows and who know him, and who therefore feel at ease together.

There are other famous and less famous pictures by Cartier-Bresson which could be regarded as portraits, but which according to him are documentary photos, because a portrait, he says, can only be of a person one knows. A very significant exclusion, like the other one of the famous photograph of Matisse surrounded by doves (page 54), which he does not regard as a portrait—wrongly, no doubt—because in a portrait, he maintains, the subject must 'give', must not be occupied with other things.

Cartier-Bresson goes on accumulating details which little by little become more than a definition of his approach to portraiture. They define his whole conception of photography as a way of life, a way of involving himself in life, endlessly asking questions and receiving immediate, astounding, answers.

The portrait is the particular way the photographer has of looking for immediate answers in a person's facial expression, and the rigorous organization of shapes which express and constitute the truth about that person and his relationship with the world and with life as the photographer sees it.

I note that, in this conversation without inverted commas, which I have had the privilege of trying to reconstruct, Cartier-Bresson goes on multiplying the rules and prohibitions, continually narrowing down the frame of reference within which he exercises his prodigious capacity for variation and creation. These rules, he insists, are not general ones, but purely for his own enjoyment and, I might add, for ours. It seems to me that these rules also define a system of ethics as well as aesthetics: the ethics of intelligence, of attention, of respect for others; the art of putting the eye, the heart and the mind in the same line of sight. They also speak of his passion, continued in his drawing, for working 'from life'.

This is why all his portraits have a familiar air about them, because his understanding of people is bound up with his own psychological make-up. In all Cartier-Bresson's portraits, we therefore also recognize his self-portrait, and our own—a miracle which only true artists know how to achieve.

Chronology

1908
Born 22 August at Chanteloup, Seine et Marne.
Attended secondary school at the Lycée Condorcet. No certificates.

1923
Became keenly interested in the painting and theories of the Surrealists.

1927–28
Studied painting in the studio of André Lhote.

1931
Travelled to the Ivory Coast, where he remained for a year.
On returning to Europe, took up photography seriously.

1932
His first photographs, exhibited at the Julien Levy Gallery in New York, were later shown to the Club Atheneo in Madrid by Ignacio Sanchez Mejias and Guillermo de Torre. Charles Peignot published them in *Arts et Métiers Graphiques*.

1934
Left for Mexico, where he spent a year with an ethnographic expedition.
Exhibited his photographs at the Palacio de Bellas Artes.

1935
Lived in the United States and became involved in the cinema with Paul Strand.
Took no photographs.

1936
Returned to France.
Second assistant director to film-maker Jean Renoir, together with Jacques Becker and André Zvoboda.

1937
Made a documentary, *Victoire de la Vie*, about the hospitals of Republican Spain during the Civil War.

1940
Taken prisoner by the Germans; managed to escape after three years in captivity and two unsuccessful attempts.

1943
Joined MNPGD, an underground movement to assist prisoners and escaped prisoners.
Took portraits of artists, painters and writers for Braun publications (Matisse, Bonnard, Braque, Claudel).

1944–45
Joined a group of professionals who photographed the liberation of Paris.
Made *Le retour*, a documentary about the return of prisoners of war and deportees.

1946
Spent more than a year in the United States, completing a 'posthumous' exhibition organized by the Museum of Modern Art in New York, who believed him lost in the war.

1947
Founded the cooperative agency Magnum Photos with Robert Capa, David Seymour and Georges Rodger.

1948–50
Spent three years in the Orient: India, Burma, Pakistan, China and Indonesia.

1952–53
Lived in Europe.

1954
Was the first photographer admitted to the USSR after the 'thaw'.

1958–59
Returned to China for three months on the occasion of the tenth anniversary of the People's Republic.

1960
From Cuba, where he made a documentary, he returned after a thirty-year absence to Mexico, where he remained for four months. Followed by a stay in Canada.

1965
Lived for six months in India and three months in Japan.

1966
Left Magnum, which, however, still manages his archives.
As in the past, his photos are printed by Pictorial Service in Paris.

1969
Spent a year preparing an exhibition, *En France*, held at the Grand Palais, Paris in 1970.
Made two documentaries for CBS News in the United States.

Since **1971**
Has concentrated on drawing and painting.

Bibliography

Books

1947, *The Photographs of Henri Cartier-Bresson*. Monograph published by the Museum of Modern Art in New York.

1952, *Images à la sauvette*. Text by Henri Cartier-Bresson. Cover by Matisse. Work devised and produced by Tériade. Éditions Verve, Paris. Published in English as *The Decisive Moment* by Simon & Schuster, New York.

1954, *Les danses à Bali*. Text by Antonin Artaud on the Balinese theatre and commentaries by Béryl de Zoete. Delpire Éditeur, Paris.

1954, *D'une Chine à l'autre*. Preface by Jean-Paul Sartre. Delpire Éditeur, Paris. UK edition: *China in Transition*, Thames & Hudson, London, 1956. American edition: *From One China to Another*, Universe Books, New York, 1955.

1955, *Les Européens*. Introduction by Henri Cartier-Bresson. Cover by Joan Miró. Work devised and produced by Tériade. Éditions Verve, Paris. *The Europeans*, Simon & Schuster, N.Y.

1955, *Moscou, vu par Henri Cartier-Bresson*. Delpire Éditeur, Paris. *People of Moscow*, Thames & Hudson, London, and Simon & Schuster, New York.

1958, *Henri Cartier-Bresson: Fotografie*. Text by Anna Farova. Published in Prague & Bratislava.

1963, *Photographies de Henri Cartier-Bresson*. Delpire Éditeur, Paris. *Photographs by Henri Cartier-Bresson*, Johnathan Cape, London, and Grossman, New York, 1964.

1964, *China*. Photographs and notes on fifteen months in China. English language edition edited by Barbara Brakeley-Miller. Bantam, New York.

1966, *The Galveston That Was*. Text by Howard Barstone. Photographs by Ezra Stoller and Henri Cartier-Bresson. Macmillan, New York and The Museum of Fine Arts, Houston.

1968, *L'homme et la machine*. Introduction by Étiemble. Work sponsored by IBM. Éditions du Chêne, Paris. *Man and Machine*, Thames & Hudson, London, and Viking Press, New York.

1968, *Flagrants délits*. Delpire Éditeur, Paris. *The World of Henri Cartier-Bresson*, Thames & Hudson, London, and Viking Press, New York.

1968, *Impression de Turquie*. Introduction by Alain Robbe-Grillet. Produced for the Turkish Tourist Office.

1970, *Vive la France*. Text by François Nourissier. Published by Sélection du Reader's Digest. Robert Laffont, Paris. *Cartier-Bresson's France*, Thames & Hudson, London, and Viking Press, New York, 1971.

1972, *The Face of Asia*. Introduction by Robert Shaplen. Published by John Weatherhill (New York and Tokyo) and Orientations Ltd (Hong Kong). French edition: *Visage d'Asie*, Éditions du Chêne, Paris. UK edition: *The Face of Asia*, Thames & Hudson, London.

1973, *A propos de l'URSS*. Éditions du Chêne, Paris. *About Russia*, Thames & Hudson, London, and Viking Press, New York, 1974.

1973, *The Decisive Moment: Henri Cartier-Bresson*. Audio-visual material in 'Images of man' series, published by Scholastic Magazines Inc., New York.

1981, *Henri Cartier-Bresson: Photographe*. Text by Yves Bonnefoy. Delpire Éditeur, Paris. American, UK, German and Japanese editions.

1982, *Henri Cartier-Bresson*. Preface by Jean Clair. 'Photo-Poche' series published by the Fondation Nationale de la Photographie, Paris.

Public collections (400 photographs)

Demenil Foundation, Houston, Texas.
Bibliothèque Nationale, Paris.
Victoria and Albert Museum, London.
University of Fine Arts, Osaka, Japan.

Exhibitions of photographs

1932, First exhibition at the Julien Levy Gallery in New York and the Atheneo Club in Madrid.

1934, Exhibition with Manuel Alvarez Bravo at the Palacio de Bellas Artes, Mexico.

1935, Exhibition with Walker Evans at the Julien Levy Gallery in New York.

1947, 'Posthumous' exhibition at the Museum of Modern Art, New York (300 photographs).

1948, Exhibition in Bombay.

1952, Exhibition at the Institute of Contemporary Arts, London.

1953, Exhibition in Florence.

1955, Exhibition of 400 photographs at the Musée des Arts Décoratifs, Paris, followed by a travelling exhibition in various museums in Europe, the United States, Canada and Japan.

1964, Exhibition at the Phillips Collection, Washington.

1965, Second retrospective exhibition, firstly in Tokyo and then at the Musée des Arts Décoratifs in Paris (1966–67). This exhibition later went to New York (1968), London (1969), Amsterdam and finally Rome, Zurich, Hamburg, Bremen, Munich, Milan, Cologne and Aspen, Colorado.

1970, 'En France' exhibition at the Grand Palais in Paris. This exhibition then toured France until 1976. It was shown in the United States (1970), the USSR (1972), Yugoslavia (1973), Australia and Japan (1974).

1974, Exhibition on Russia (1953–1974) at the International Center of Photography in New York.

1975, Tribute to Henri Cartier-Bresson at the Triennial International Photography Exhibition presented by Michel Terrapon in Fribourg, Switzerland.

1981, Together with the International Center of Photography in New York, Robert Delpire put on an exhibition which toured the principal museums of Europe and America for three years.

1982, 'Portraits, 1932–1982'. Galerie Eric-Franck, Geneva.

Exhibitions of drawings

1975, First exhibition at the Carlton Gallery, New York.
1976, Exhibition at the Bischofsberger Gallery in Zurich.
1976, Exhibition at the Lucien Henry Gallery, Forcalquier.
1981, Exhibition at the Musée d'Art Moderne de la Ville de Paris.
1982, Exhibition at the Museo d'Arte Moderna, Mexico City.
1983, Exhibition at the Institut Français, Stockholm.

Films

Second assistant director to Jean Renoir for *La vie est à nous* and *Une partie de campagne* in 1936 and *La règle du jeu* in 1939.
Henri Cartier-Bresson himself made:

1937, *Victoire de la Vie* about the hospitals of Republican Spain, with cameraman Jacques Lemare.

1944–45. *Le retour*. Documentary on the homecoming of prisoners of war and deportees, produced by the OWI and Ministry of Prisoners.

1969–70, Two documentaries for CBS News:
Impressions of California
with cameraman Jean Boffety; and
Southern exposures
with cameraman Walter Dombrow.

1967, *Flagrants délits*. Still frame film produced by Robert Delpire. Original music by Diego Masson. Delpire production, Paris.

Index of photographs

Authors

André Pieyre de Mandiargues, the highly
regarded French writer and Surrealist, was
born in Paris in 1909. He has been a close
friend of Henri Cartier-Bresson from an
early age. He won the Prix Goncourt in
1967 for his novel *La Marge* (*The Margin*).
He is perhaps best known to the English-
speaking world for his novel *Girl on the
Motorcycle* (*La Motocyclette,* 1963) which
was made into a successful film.

Ferdinando Scianna was born in Bagheria,
Sicily, in 1943. He studied at the
University of Palermo, specializing in Art
History. In 1962, he met the Sicilian
writer Leonardo Sciascia, who became a
close friend and contributed an essay to
his major work, *Feste Religiose in Sicilia*
(Sicilian Religious Festivals), a collection
of photographs published in 1965, from
which a documentary film was also
produced. He moved to Milan in 1966 and
became a photographer for the weekly
news magazine *L'Europeo,* travelling
throughout the world. In 1974, he was sent
to Paris as correspondent for *L'Europeo,*
and also wrote for French publications.
Other publications include a work on
architecture, *Palermo Liberty*. His work
has been exhibited in many countries,
including the USA, China and Brazil.

Series Consultant Editors

Romeo Martinez has worked in
photographic journalism for over 50 years.
Resident in Paris, he is the author of several
books on the history of photography and is
the editor of the *Bibliothek der Photographie*
series. He was responsible for the relaunch
on the international market of the magazine
Camera. From 1957 to 1965, he organized
the biennial photographic exhibitions in
Venice. Romeo Martinez organized the
iconographic department at the Pompidou
Centre in Paris. He is a member of the
Administration Council and of the Art
Commission of the Societé Français de
Photographie and a member of the
Deutsche Gesellschaft für Photographie.

Bryn Campbell has been active both as a
professional photographer and as an editor
and writer on photography. He is known to
many as the presenter of the BBC TV series
Exploring Photography. As a photographer,
he has worked for a Fleet Street agency,
with *The Observer,* and on assignments for
Geo and *The Observer Magazine*. He has
been Assistant Editor of *Practical
Photography* and of *Photo News Weekly*,
Editor of *Cameras & Equipment,* Deputy
Editor of *The British Journal of Photography*
and, from 1964 to 1966, Picture Editor of
The Observer.

In 1974 he was made an Honorary
Associate Lecturer in Photographic Arts at
the Polytechnic of Central London. The
same year he was appointed a Trustee of the
Photographers' Gallery, London. He served
on the Photography Sub-Committee of the
Arts Council and later became a member of
the Art Panel. He is a Fellow of the Institute
of Incorporated Photographers and a
Fellow of the Royal Photographic Society.
His book *World Photography* was published
in 1981.

Acknowledgements

My friend Romeo Martinez is, in my
humble opinion, the father confessor of a
number of photographers who come to
him to beg for absolution. His sin is in
never having asked for anything in
exchange for this devotion of his to
photography. That is why I am dedicating
this book to him. Martinez knows more
about each of us than we do ourselves.

I wish to thank Maurice Coriat for the
elegance and perspicacity with which he
has laid out this volume; Daniel Arnault,
for having 'immersed himself' so many
times in my archives at Magnum, in order
to 'retrieve' these pictures; also, André
Pieyre de Mandiargues, Ferdinando
Scianna and Lambert Vitali for their
unfailing support.

I wish to thank Martine C-B. and Jean
Genoud for their invaluable advice and
also Eric and Dominique Franck, who
organized the exhibition in Geneva, a
prelude to this book, which could never
have been produced without the
wholehearted cooperation of the printers
at Pictorial Service.

Henri

First published in 1984 by
William Collins Sons & Co Ltd
London · Glasgow · Sydney
Auckland · Johannesburg

© 1983 Gruppo Editoriale Fabbri S.p.A.,
Milan

ISBN 0 00 411947 9

Typesetting by Chambers Wallace, London
Printed in Italy